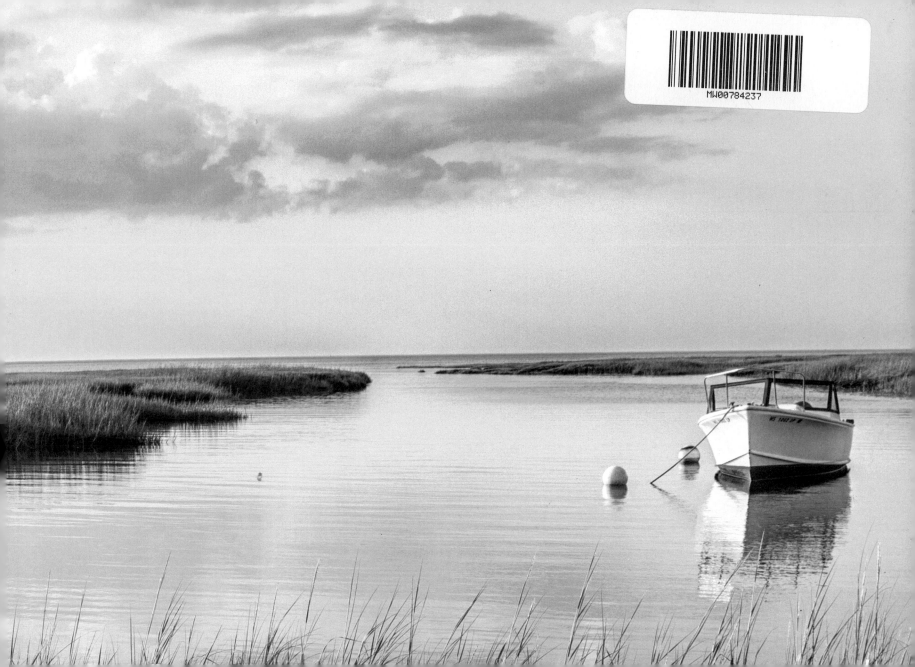

John Tunney

FOUR SEASONS OF CAPE COD

Schiffer Publishing Ltd

4880 Lower Valley Road · Atglen, PA 19310

Designed by Brenda McCallum
Cover Design John Cheek
Type set in Nexus Sans/Nexus Serif
ISBN: 978-0-7643-4993-5

Printed in China
Published by Schiffer Publishing, Ltd.
4880 Lower Valley Road
Atglen, PA 19310
Phone: (610) 593-1777; Fax: (610) 593-2002
E-mail: Info@schifferbooks.com

For our complete selection of fine books on this and related subjects, please visit our website at www.schifferbooks.com. You may also write for a free catalog.

This book may be purchased from the publisher. Please try your bookstore first.

We are always looking for people to write books on new and related subjects. If you have an idea for a book, please contact us at proposals@schifferbooks.com.

Schiffer Publishing's titles are available at special discounts for bulk purchases for sales promotions or premiums. Special editions, including personalized covers, corporate imprints, and excerpts can be created in large quantities for special needs. For more information, contact the publisher.

CONTENTS

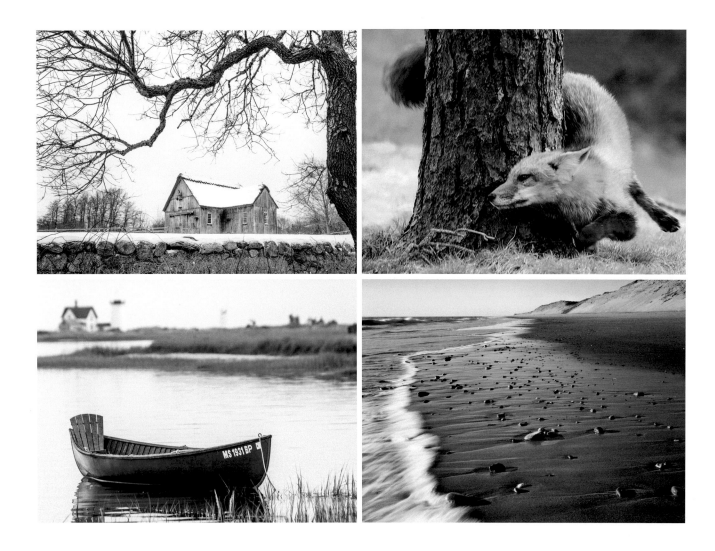

To my wife, Donna, for convincing me to move to Cape Cod and for her love, encouragement, and much more.

WINTER

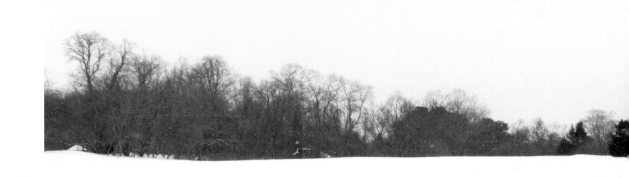

Most of the tourists

and part-time residents

are gone.

Many businesses

are closed.

Beaches, harbors, and streets

are empty.

A Cape Cod farm blanketed with snow.

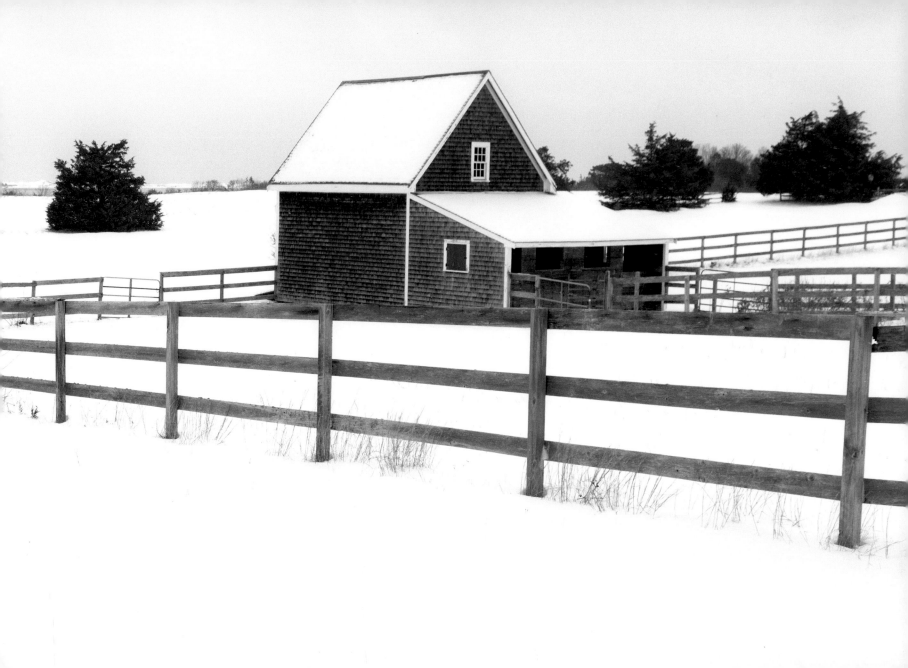

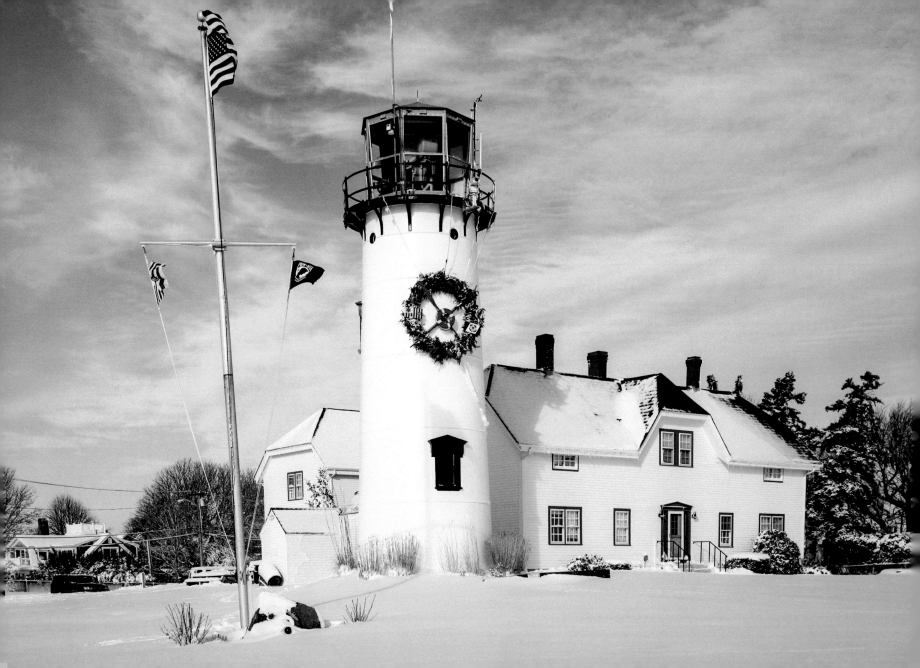

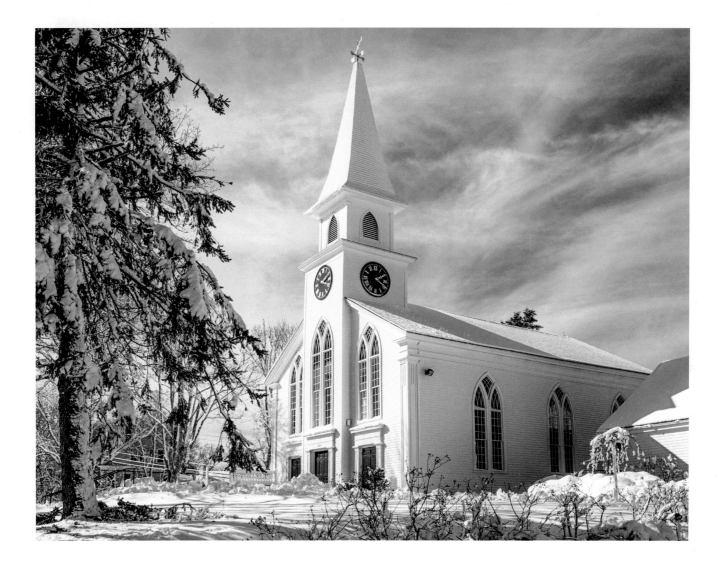

OPPOSITE Chatham Lighthouse decked out for the holidays. | Brewster's First Parish Church was built about 150 years ago.

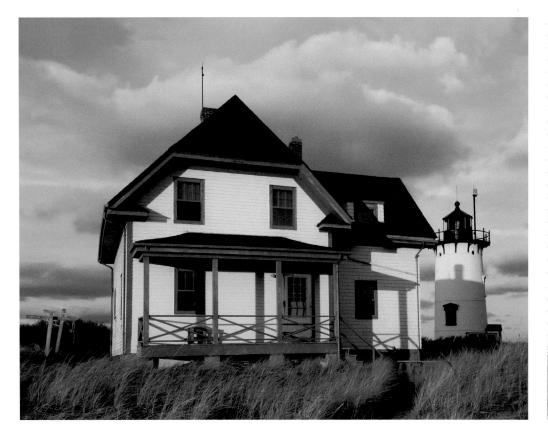

Lightkeeper's cottage at Race Point Lighthouse in Provincetown. | The setting sun in the window at Race Point captures the winter mood.

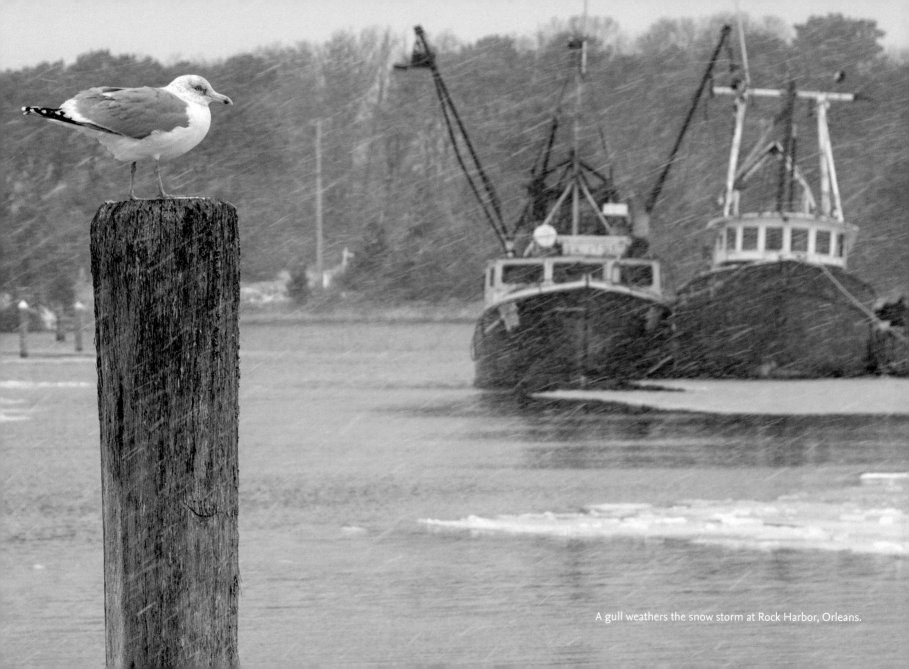

A gull weathers the snow storm at Rock Harbor, Orleans.

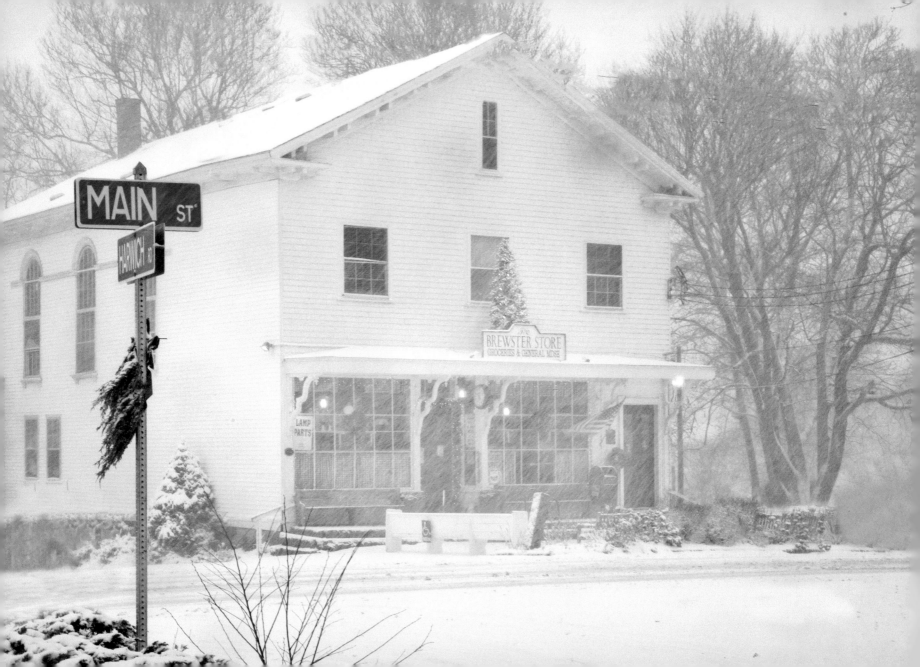

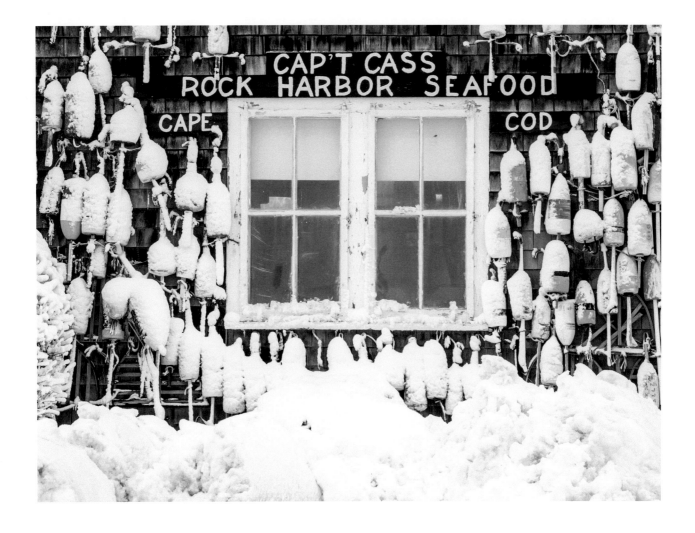

OPPOSITE The Brewster General Store was built in the mid-nineteenth century as a church. | Captain Cass—closed for the season.

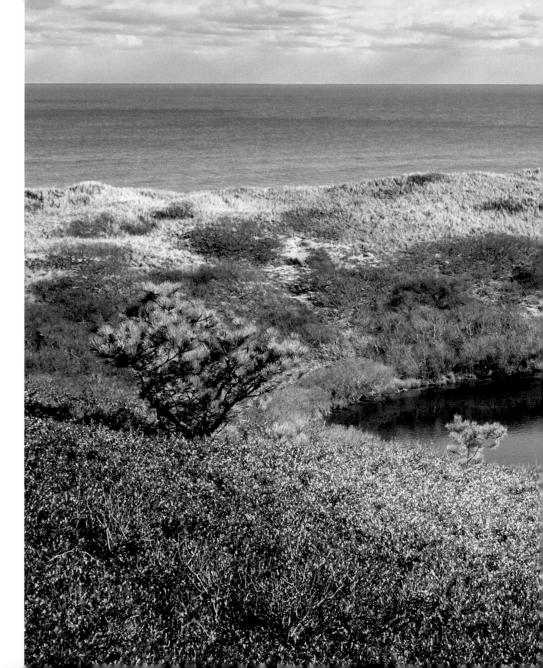

From the summit of Mount Cod (aka Bearberry Hill) you have views over the hills, kettles, and old cranberry bogs out to the Atlantic. The trail starts at the end of North Pamet Road.

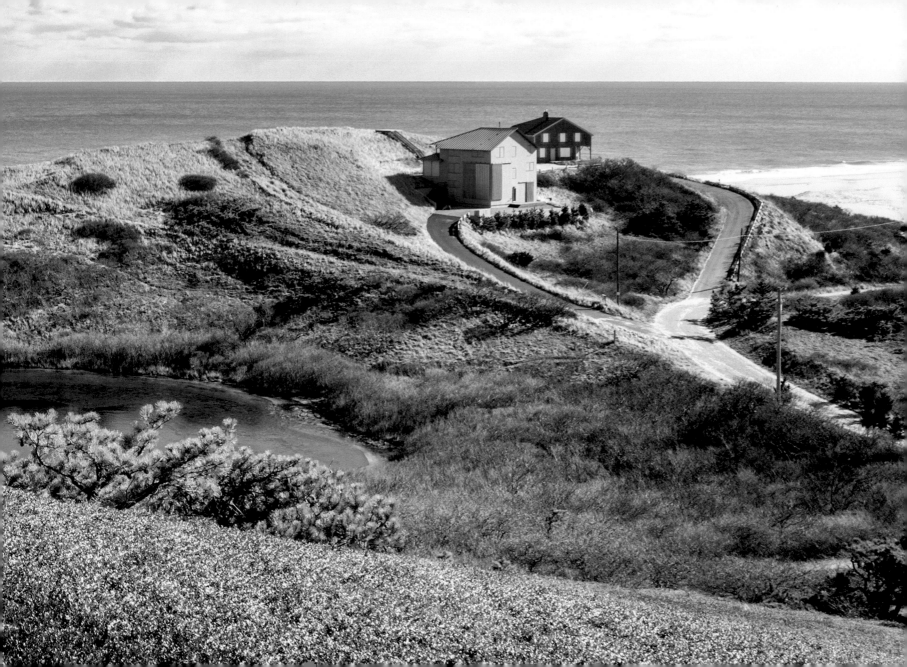

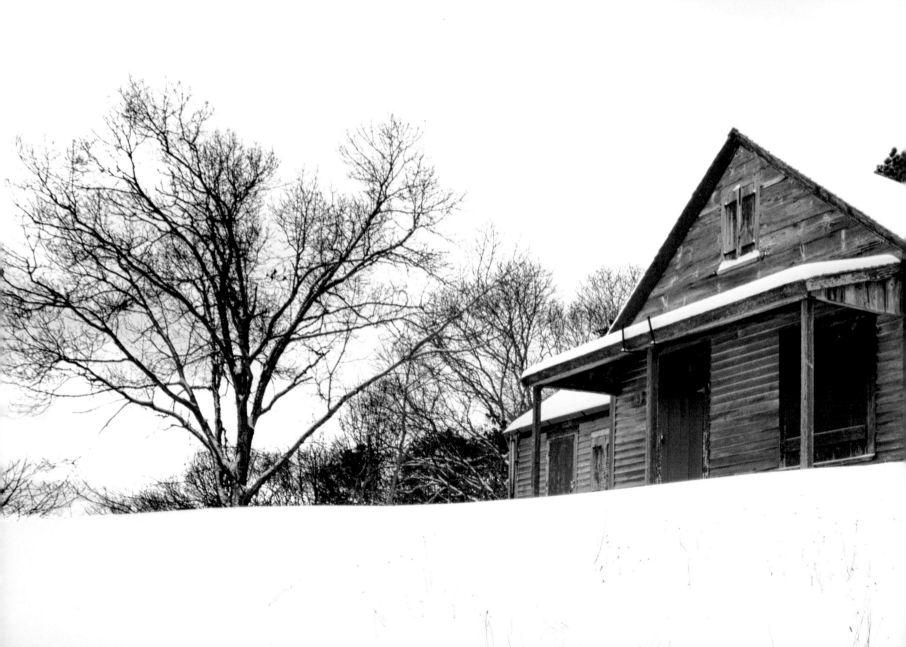

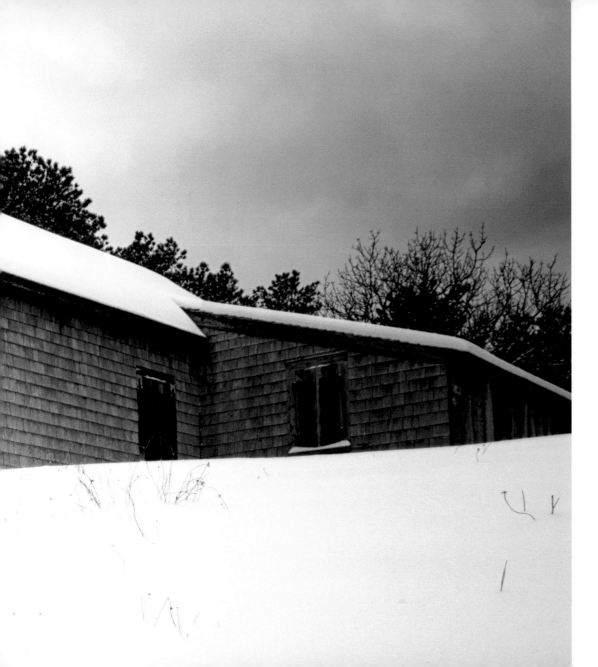

Atwood-Higgins farmstead after a snowstorm.

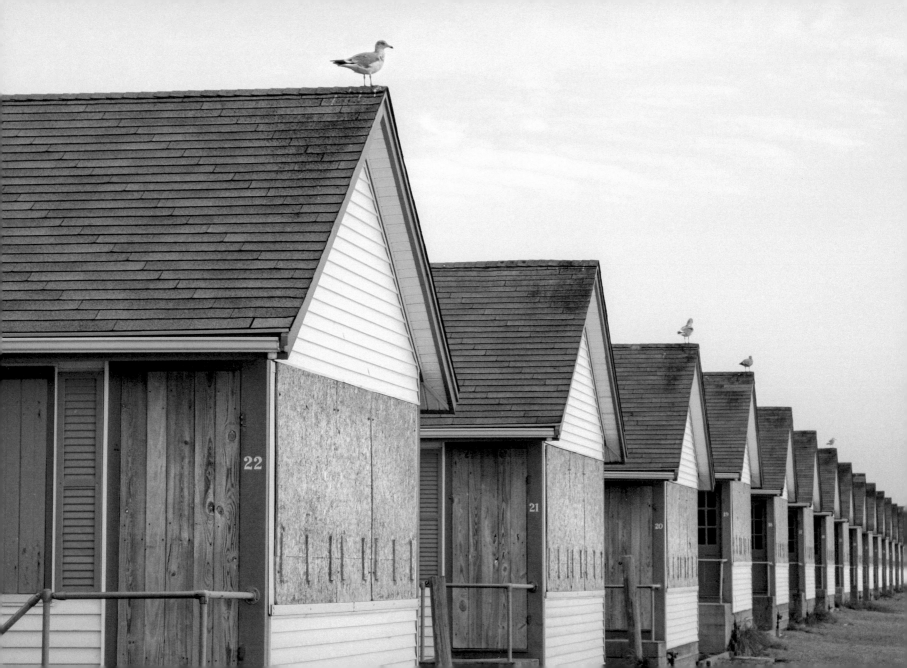

WINTER

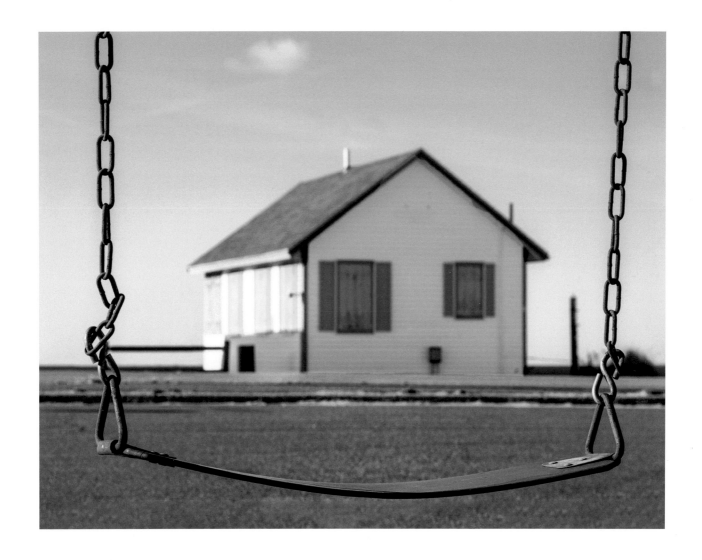

OPPOSITE Days' Cottages in North Truro are a favorite icon for artists. | One of Days' Cottages in late afternoon winter light.

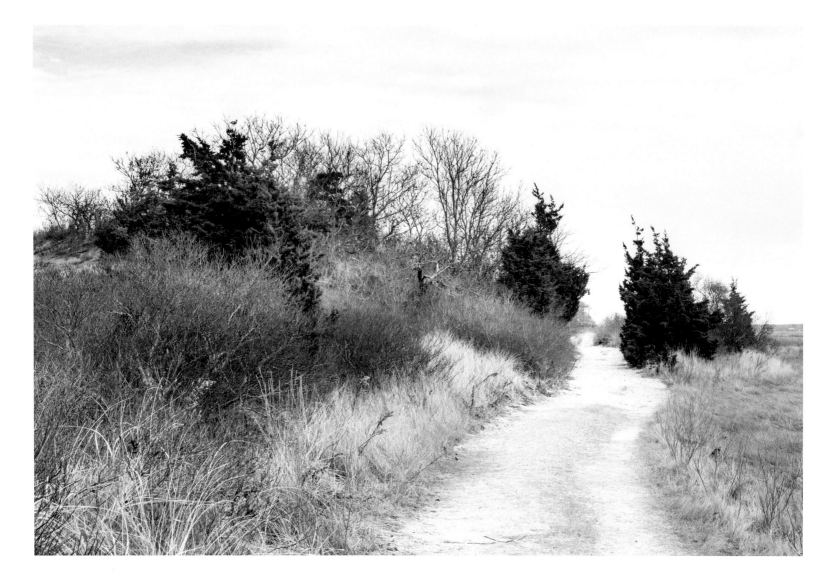

Winter covers the dunes of Barnstable's Sandy Neck with subtle colors. | OPPOSITE The wind erodes a dune in Sandy Neck.

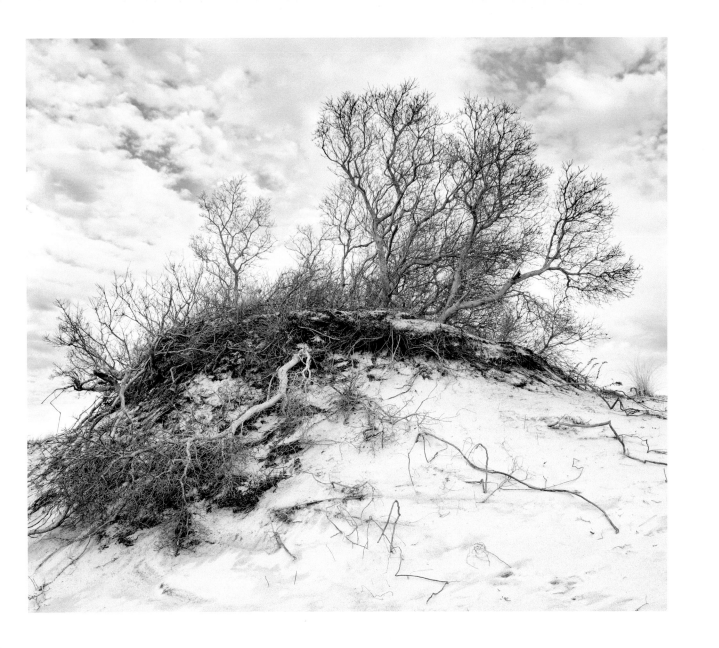

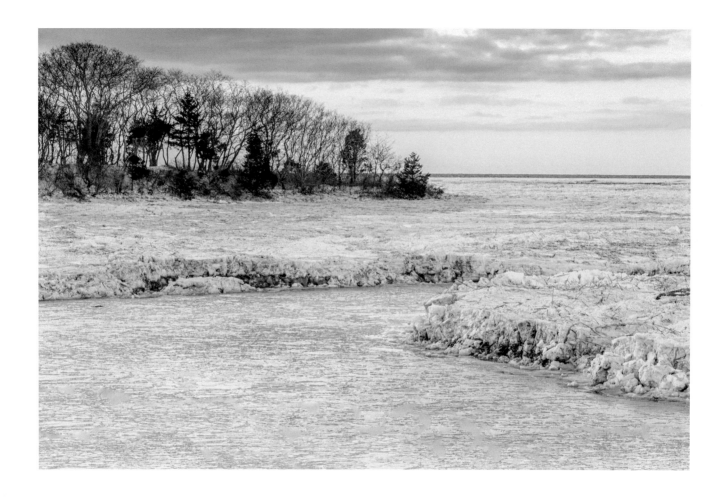

The view from Bridge Road, Eastham. | OPPOSITE Paine's Creek, Brewster.

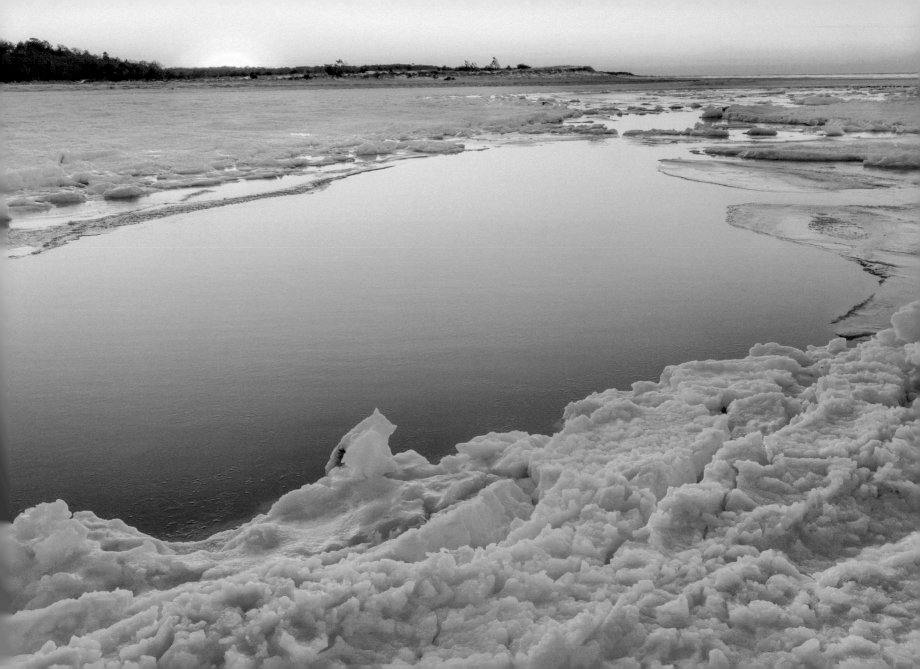

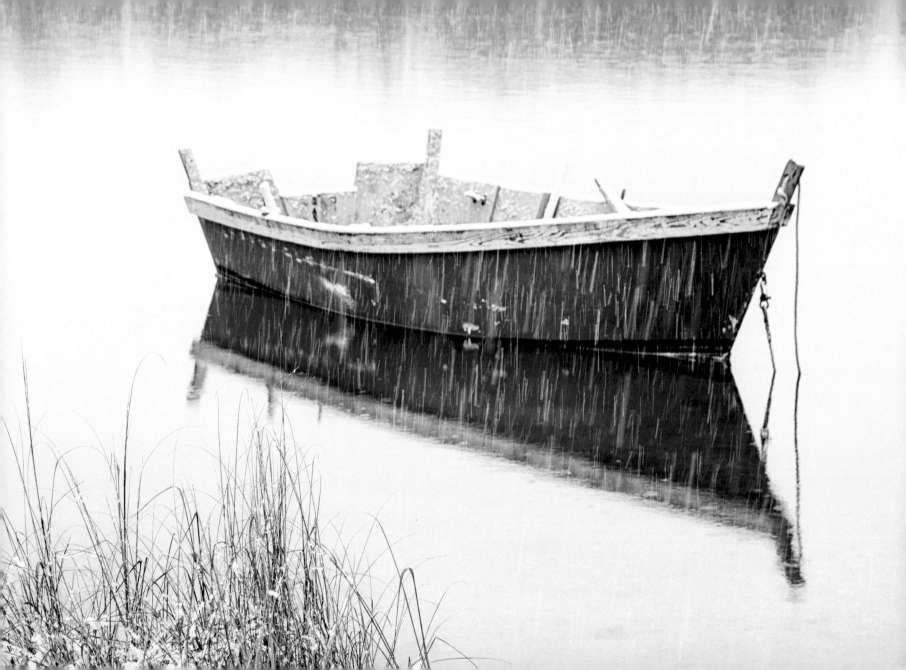

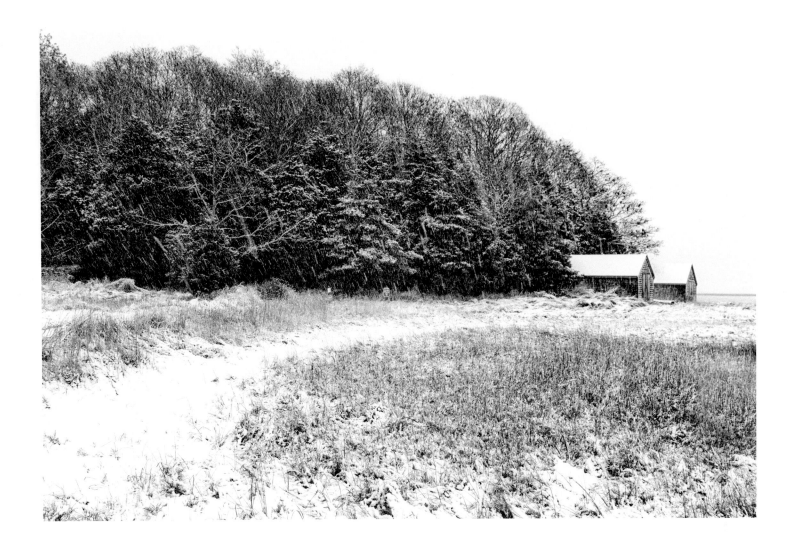

OPPOSITE Snow at Salt Pond, Eastham. | The trail along Salt Pond, Eastham, toward Nauset Marsh.

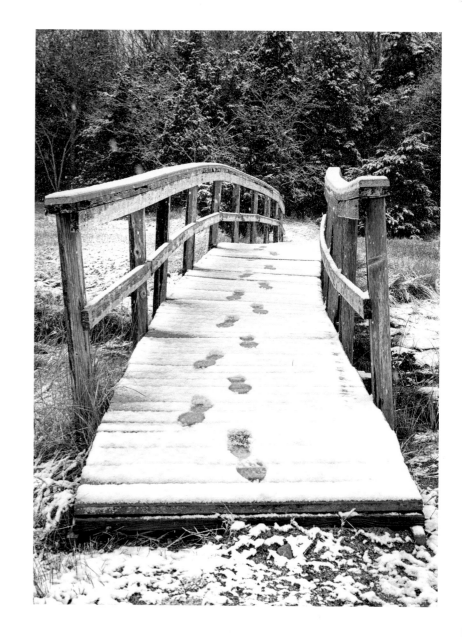

Footprints in the snow across the bridge at Salt Pond, Eastham. |
OPPOSITE A grey seal lies on the sand at Nauset Beach, Orleans.

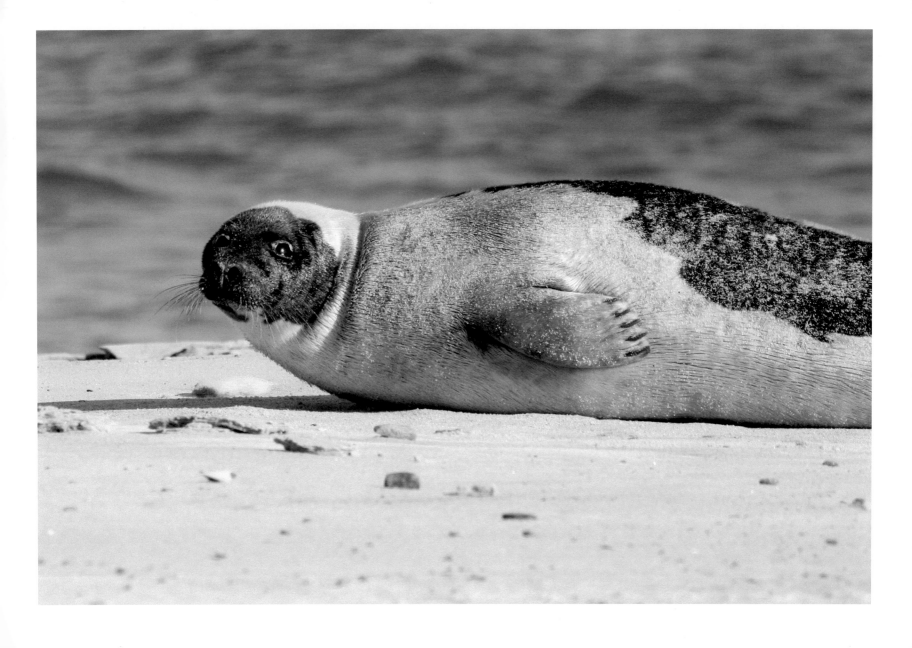

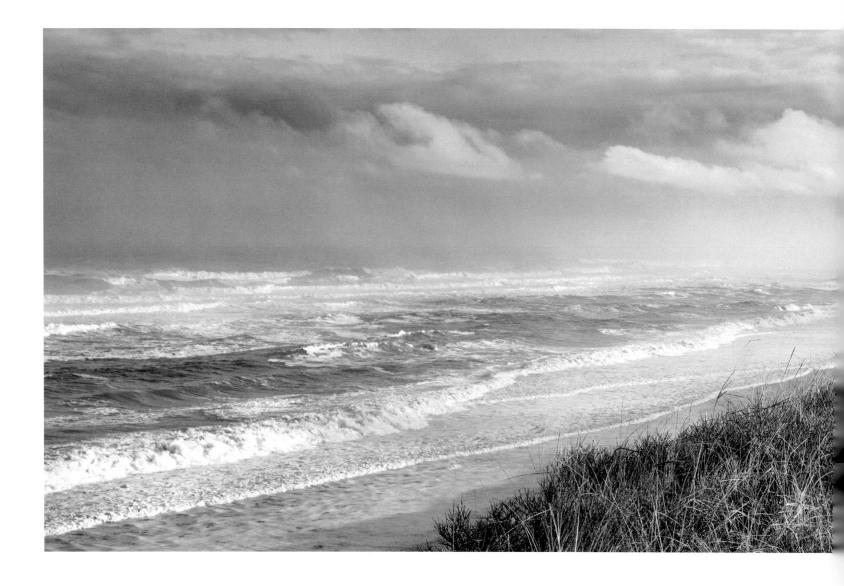

Above Ballston Beach, Truro. | OPPOSITE Highland Lighthouse, Truro.

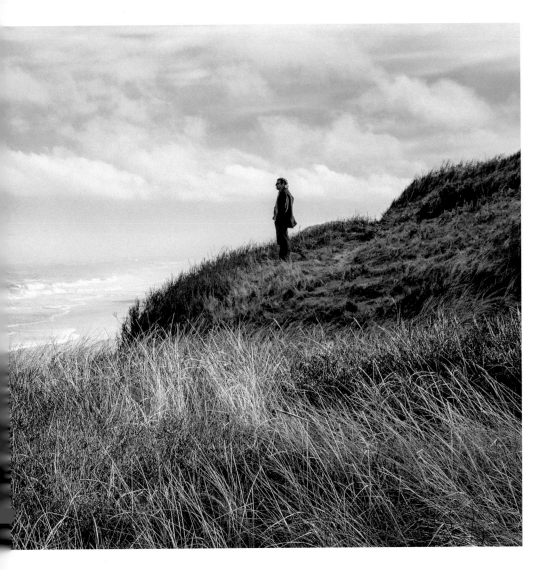
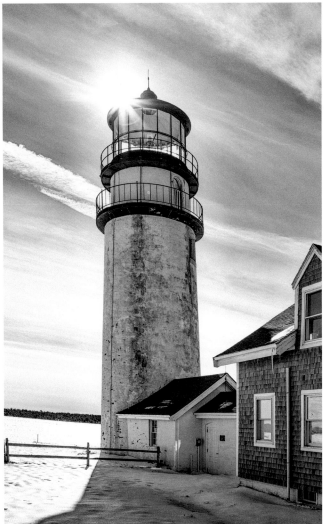

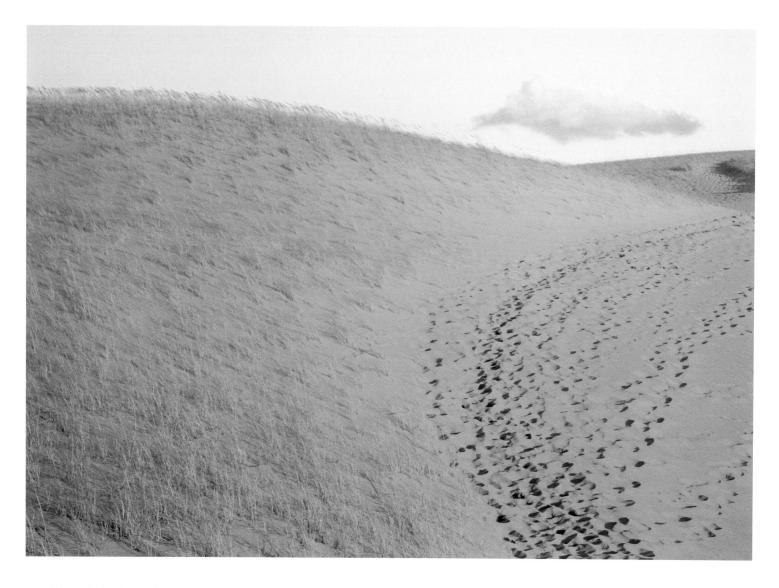

A trail through the dunes of the National Seashore's Province Lands in Provincetown.

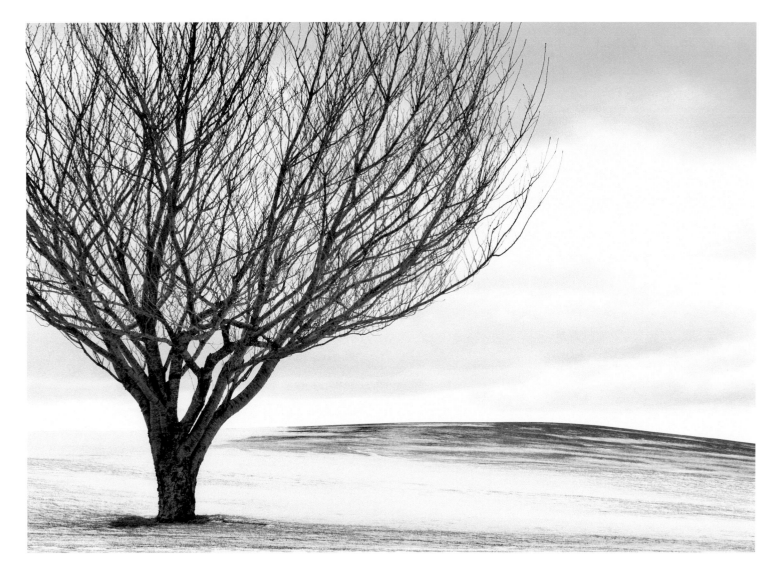

A golf course in Falmouth takes on a stark look in winter.

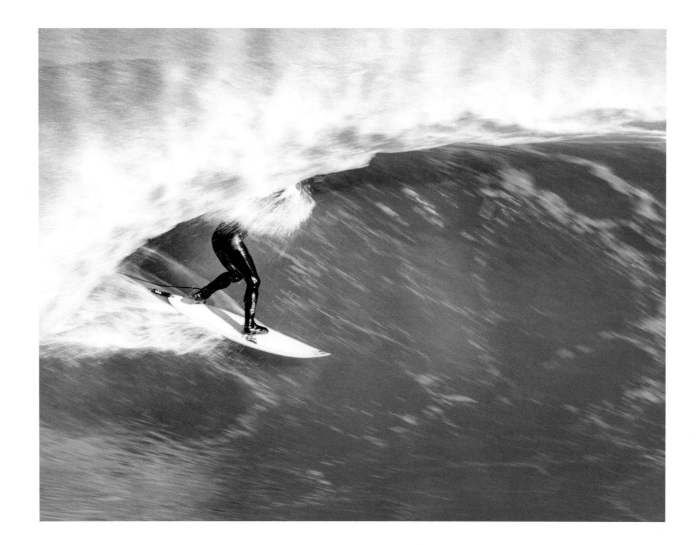

Even in January the Cape Cod surfers catch the waves. | OPPOSITE A slow exposure and panning capture the textures of a winter wave.

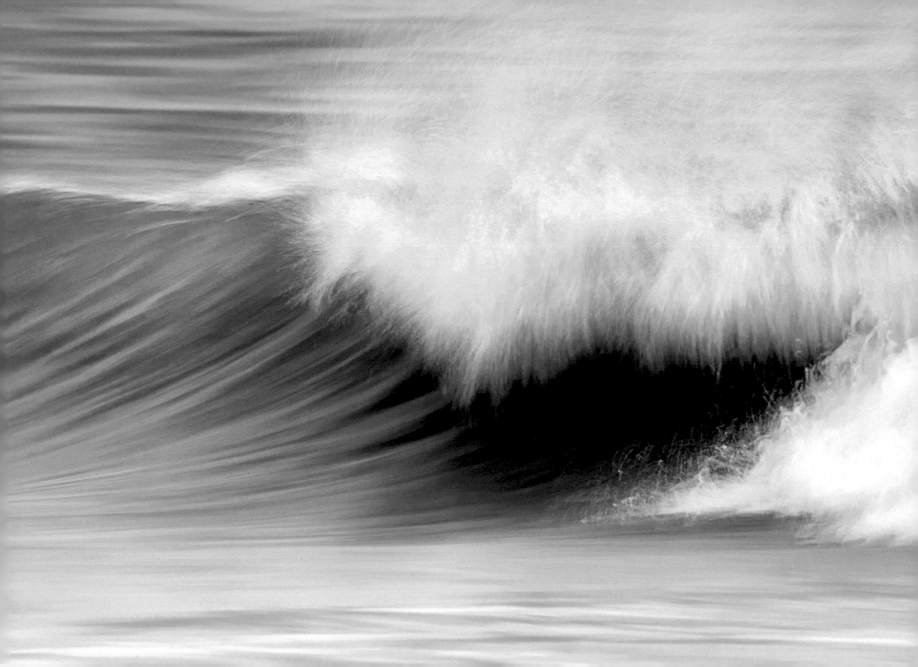

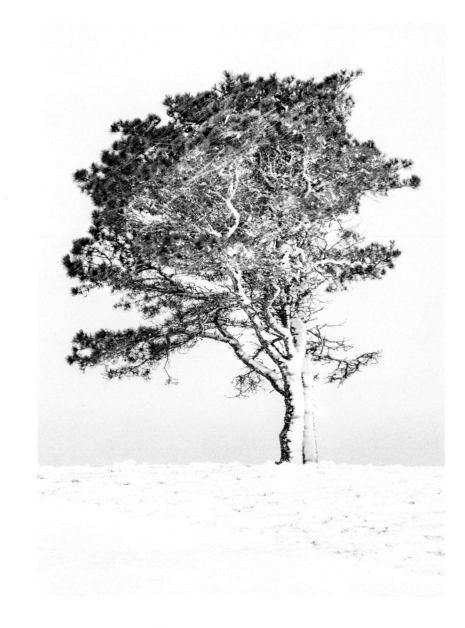

A winter storm blasts a lone pine tree. |
OPPOSITE Snow covers a thatched roof barn in Barnstable.

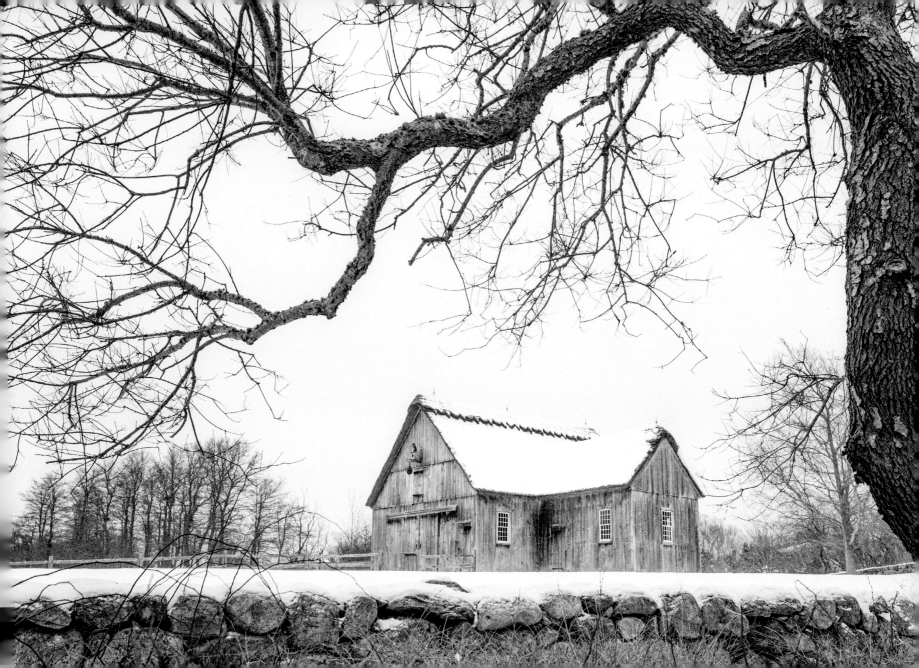

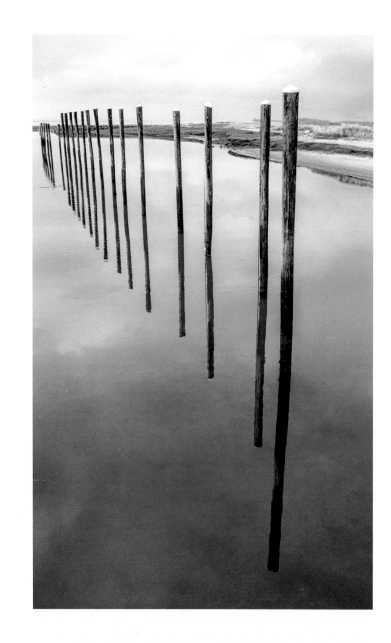

Empty boat slips at Rock Harbor. |
OPPOSITE A gull flies low between the trees that mark the channel at Rock Harbor.

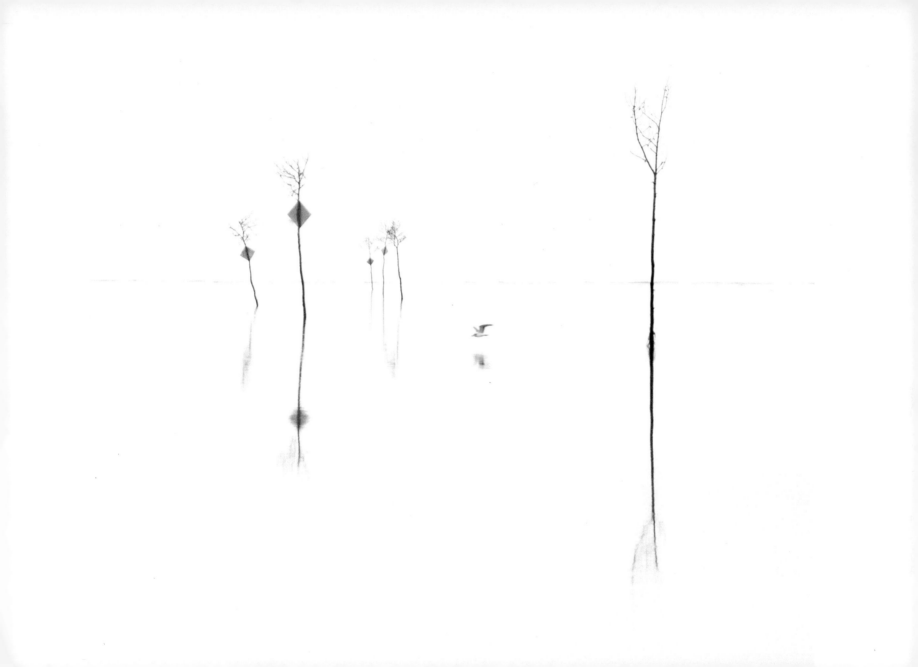

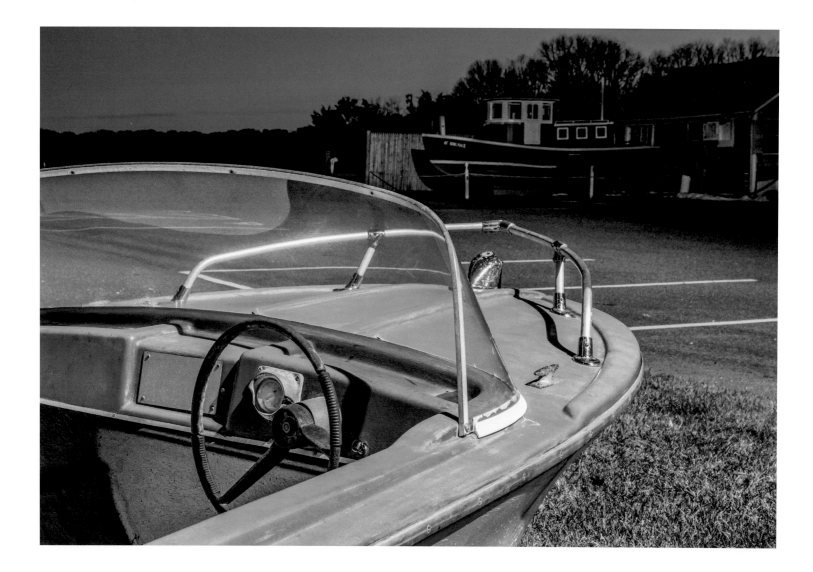

Closed for the season on Route 28 in Yarmouth.

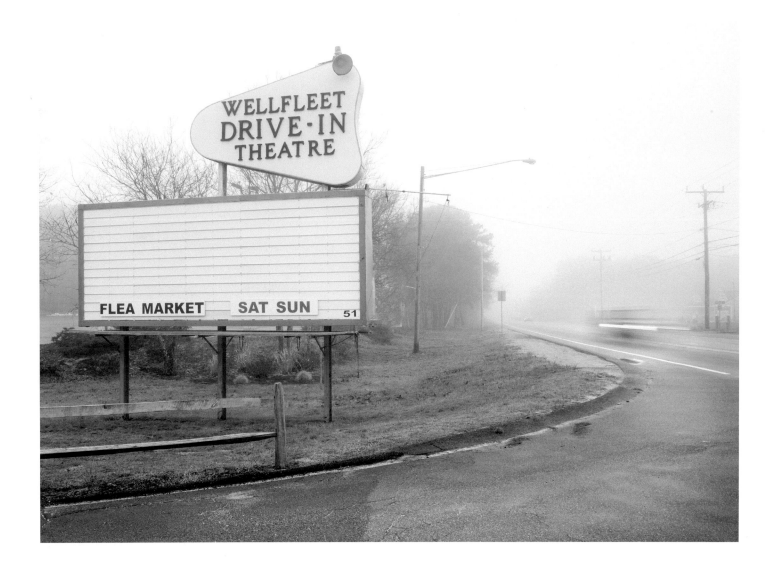

Wellfleet's drive-in theater.

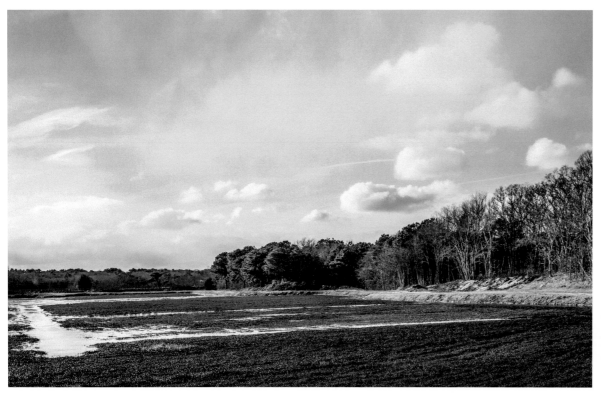

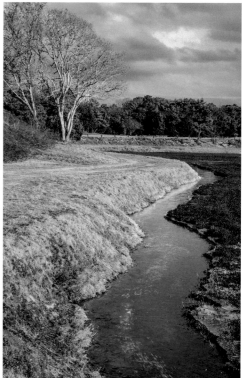

The cranberries were picked long ago and the chlorophyll in the dormant stems has turned red, giving the bogs a cranberry hue in winter. | RIGHT Cranberry bog, Harwich.

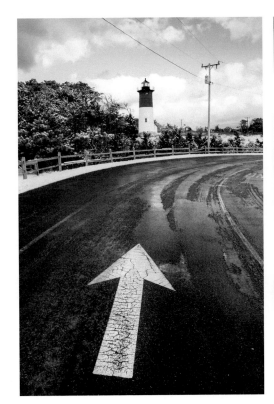

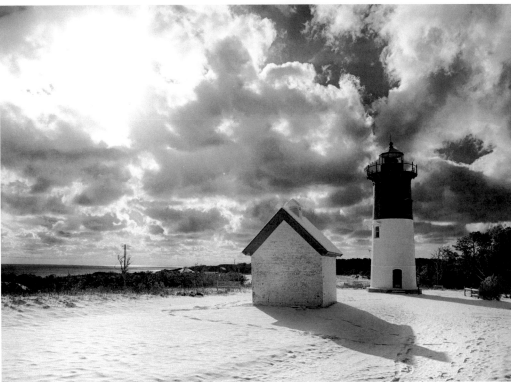

The road to Eastham's Nauset Light. | RIGHT Light from the winter sun creates deep shadows at Nauset Light.

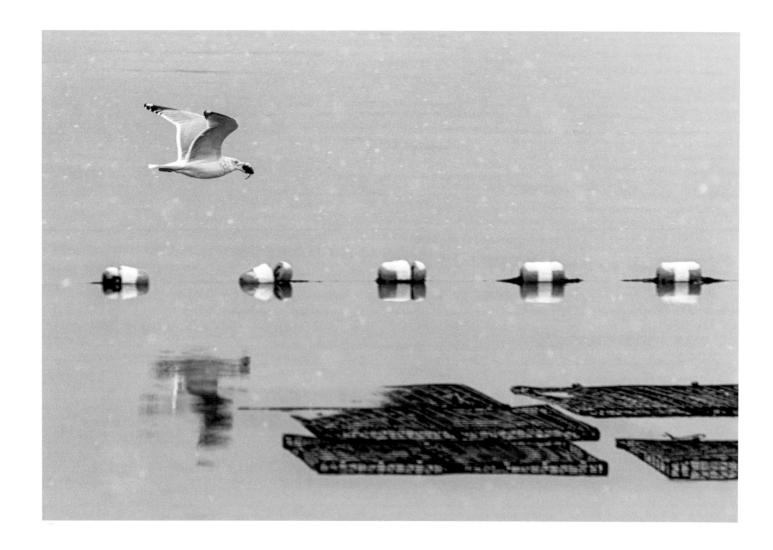

A gull with dinner flies over oyster beds. | OPPOSITE An old dock in Turo.

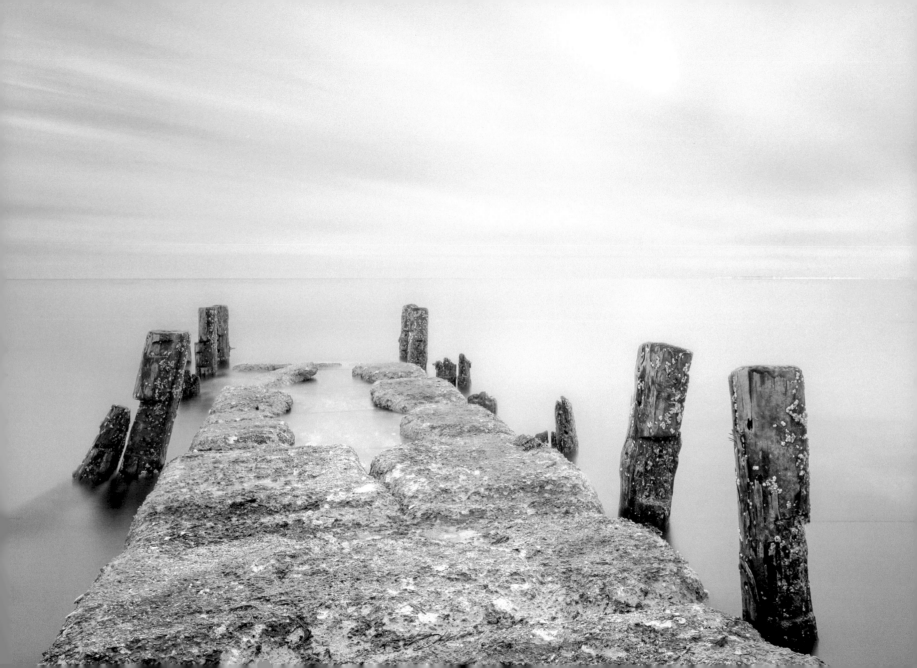

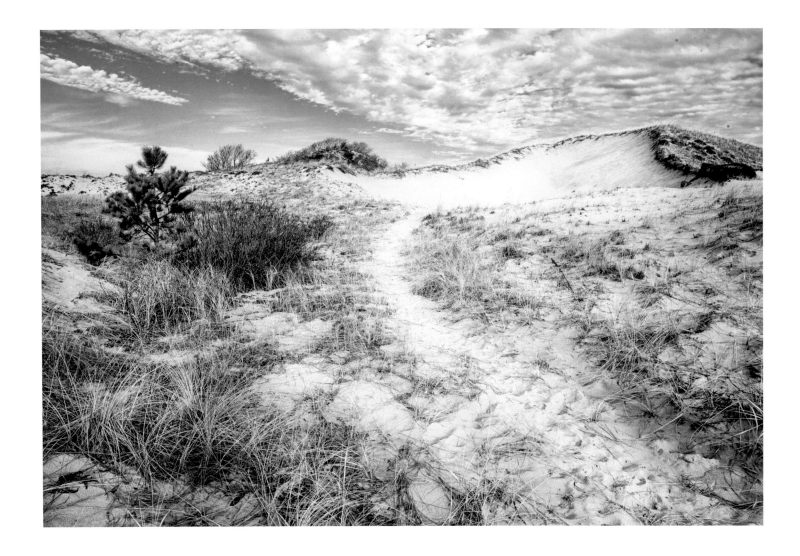

Blue skies over a dune at Sandy Neck.

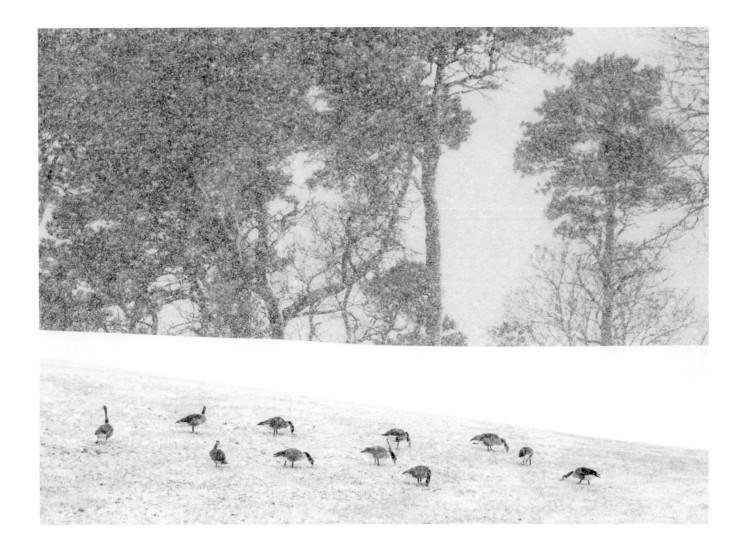

Geese don't seem to mind the snow.

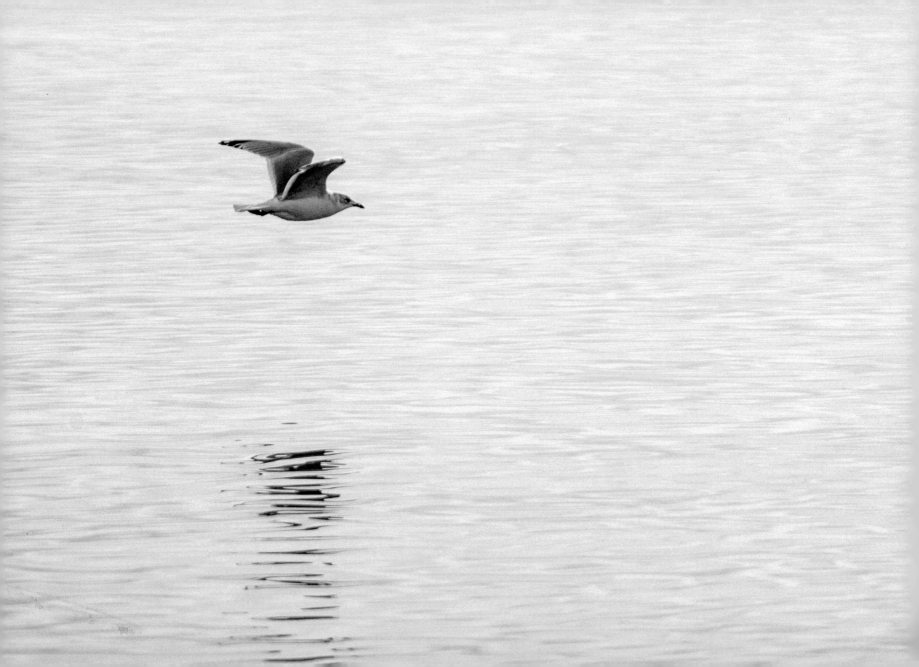

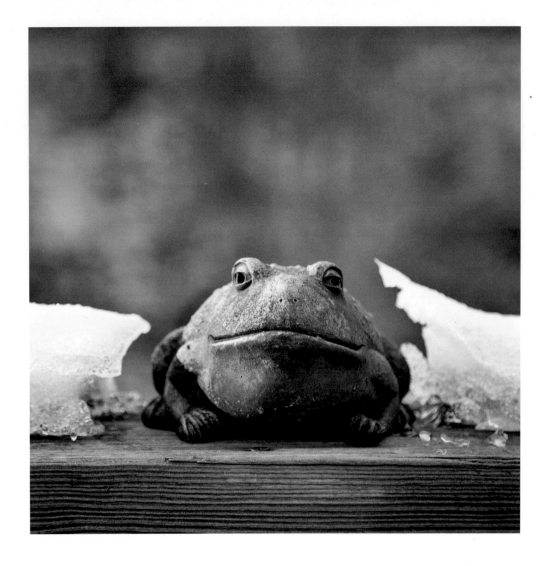

OPPOSITE Late afternoon light on the water. | Winter thaw.

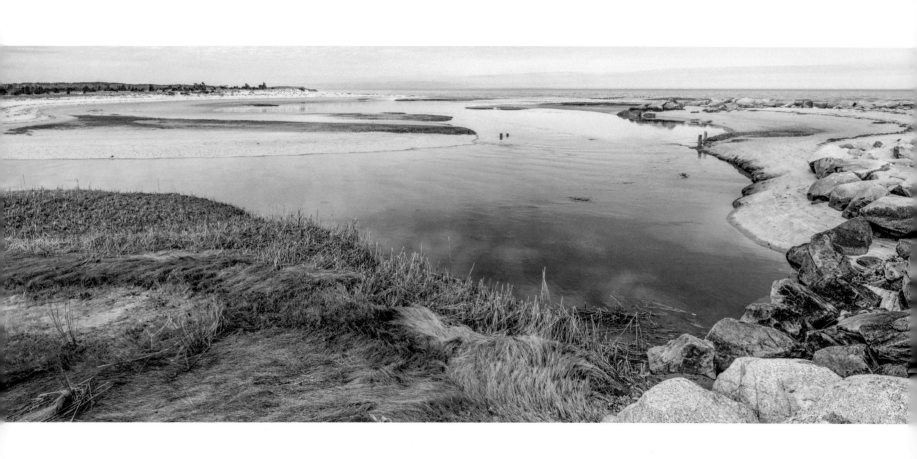

Paine's Creek, Brewster, toward the end of winter.

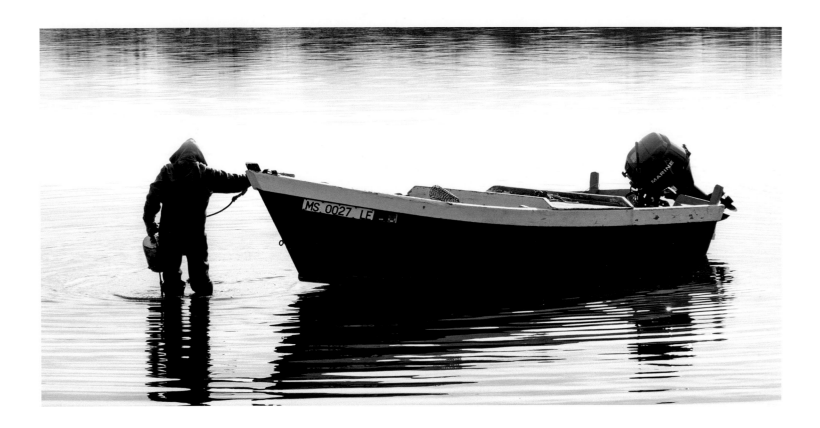

Fishermen work the waters year-round.

SPRING

The joke on Cape Cod

is that we don't have a spring.

There's winter and then,

sometime in June, someone flips

a switch and summer starts.

The truth is that spring starts late,

but once it pops the Cape feels

crisp and fresh.

Lupines at Fort Hill, Eastham.

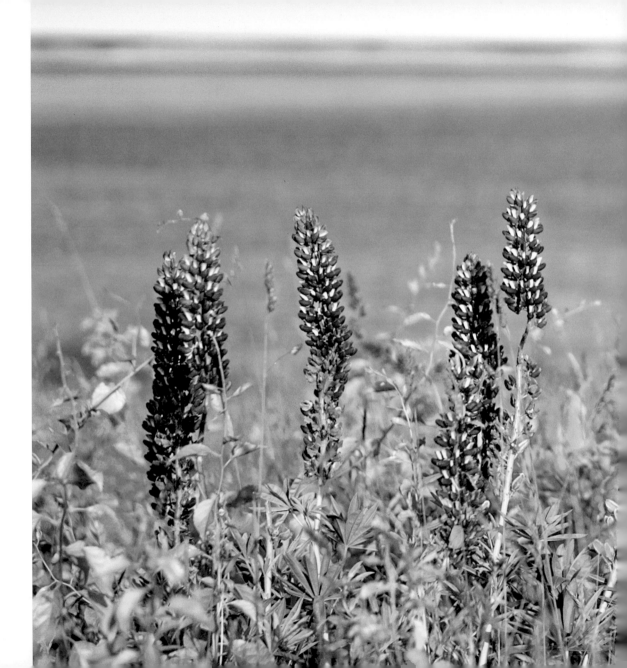

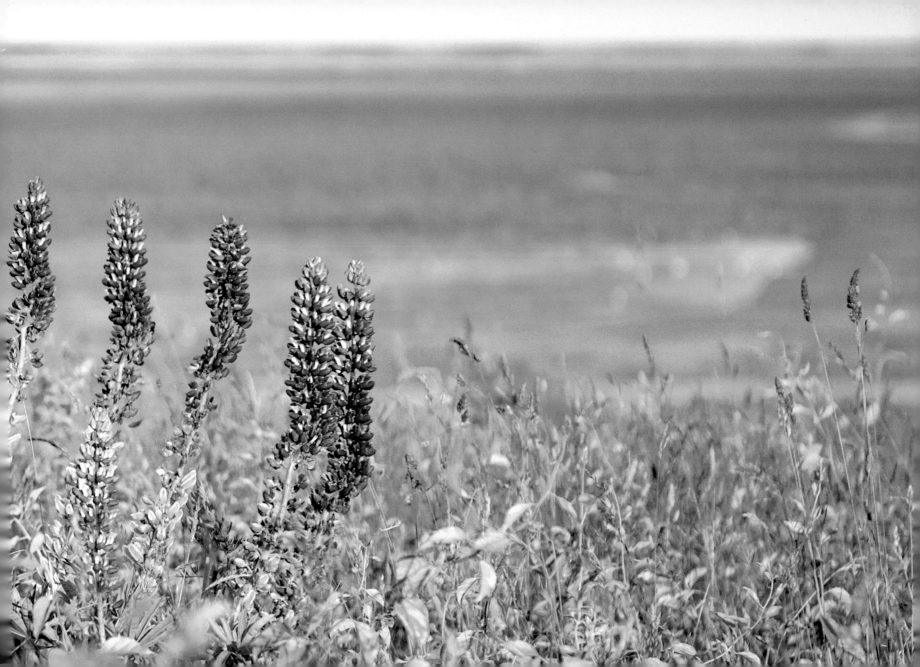

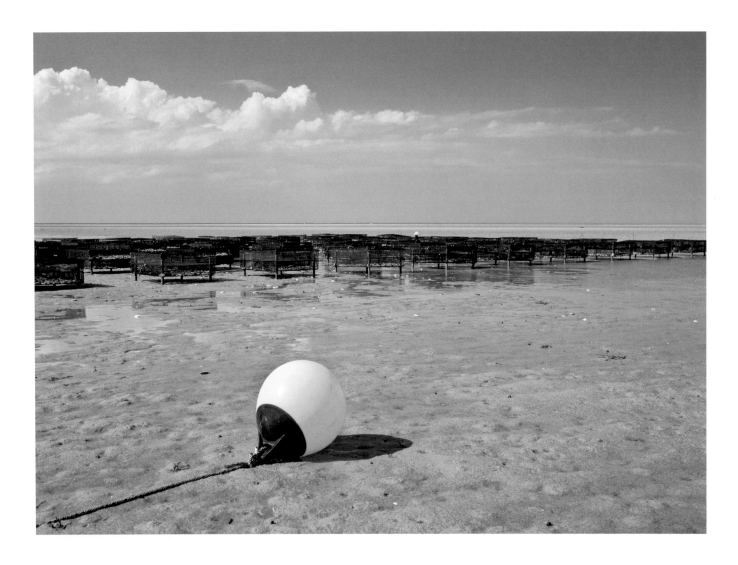

Oyster Farm on Cape Cod Bay, Dennis. | OPPOSITE Ospreys return to the Cape in early spring (Barnstable Harbor).

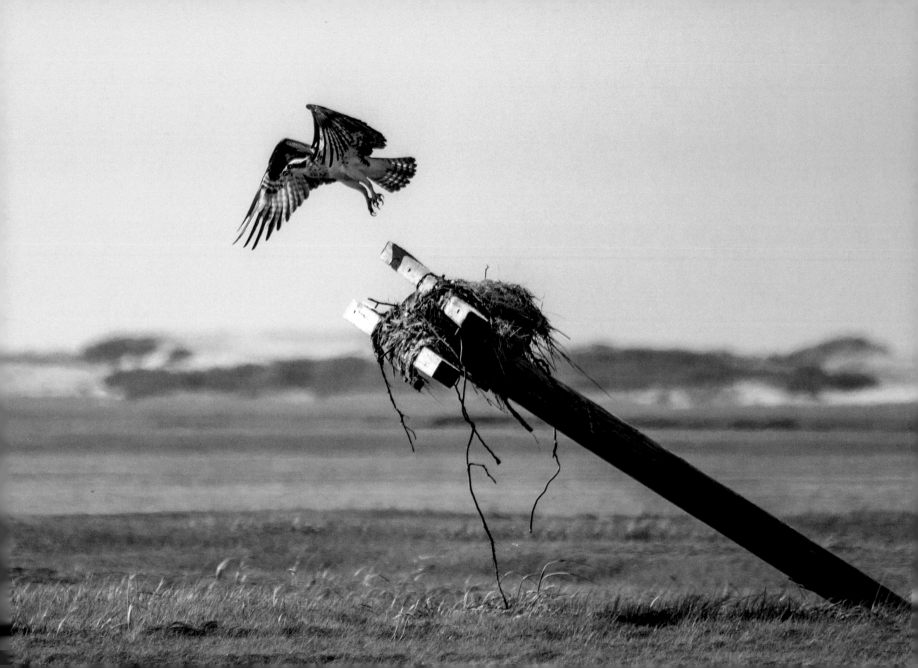

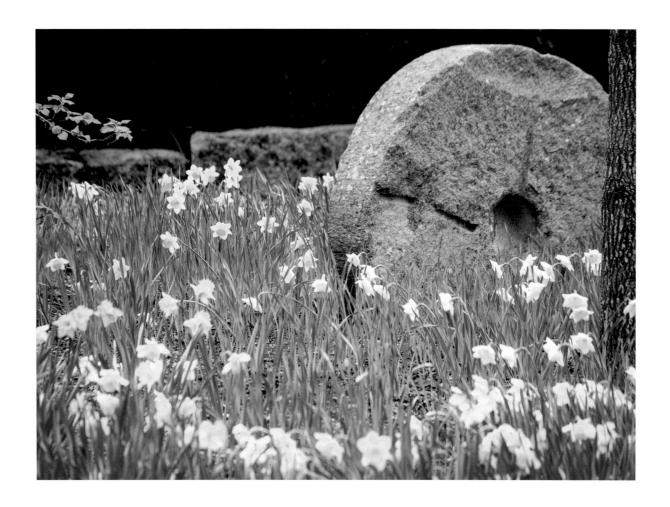

Spohr Gardens, Falmouth. | OPPOSITE Paine's Creek in early spring.

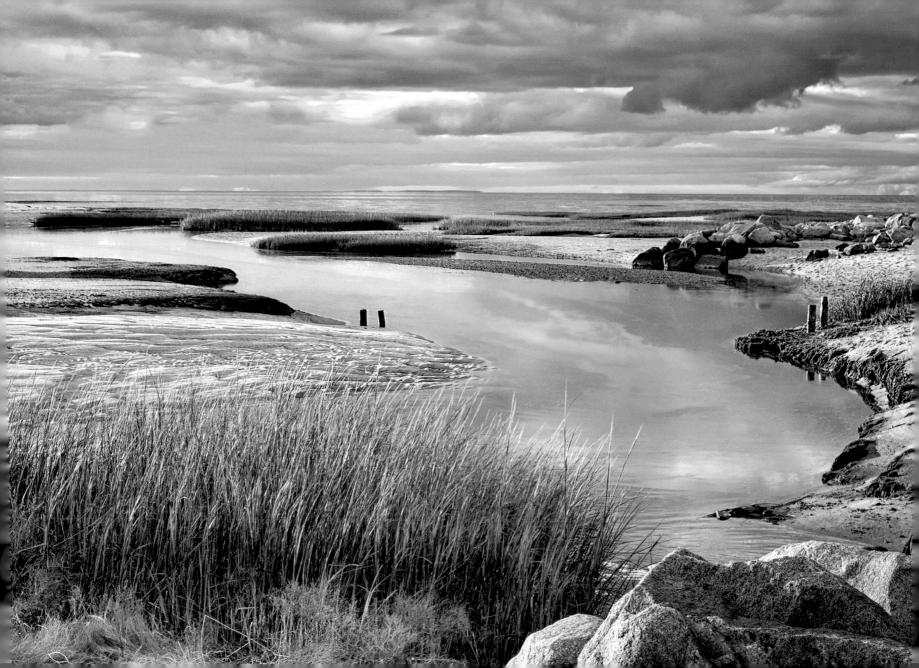

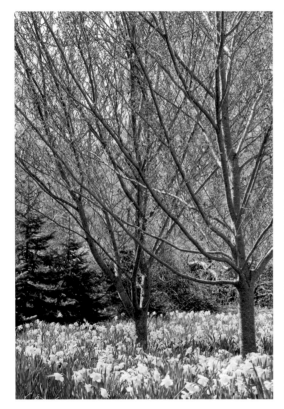

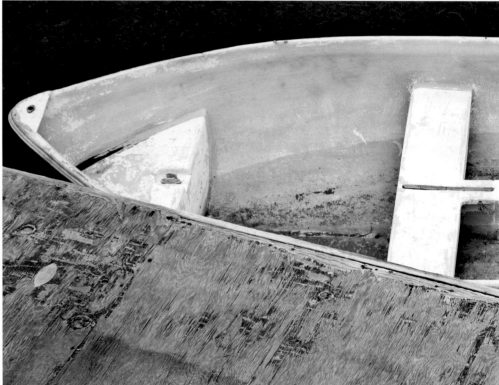

Daffodils bloom and trees start to bud in mid-April. | RIGHT This boat and dock have been through many seasons.

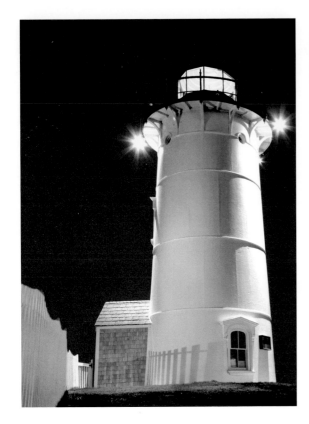
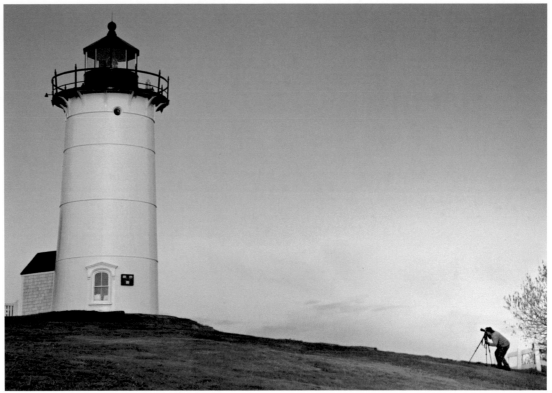

Nobska Lighthouse, Woods Hole. | RIGHT Nobska Lighthouse and photographer.

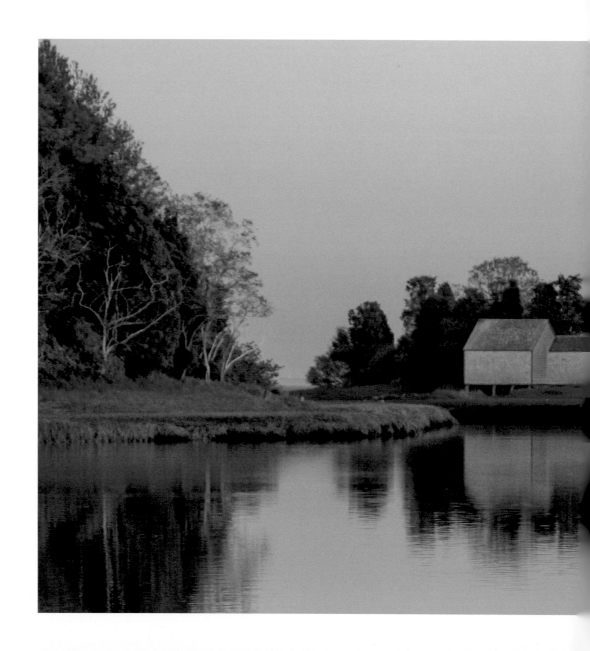

Along the channel to Salt Pond Bay and Nauset Marsh.

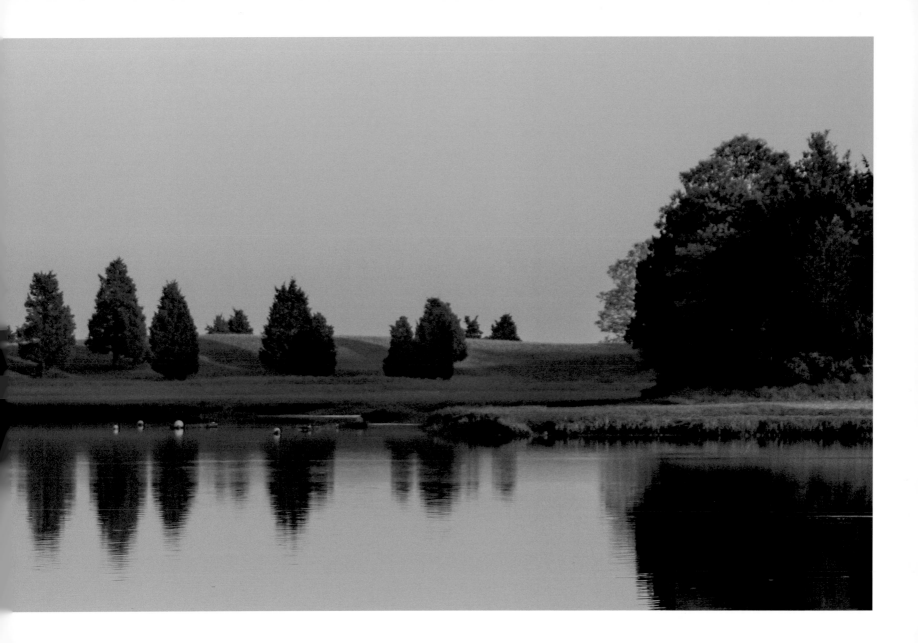

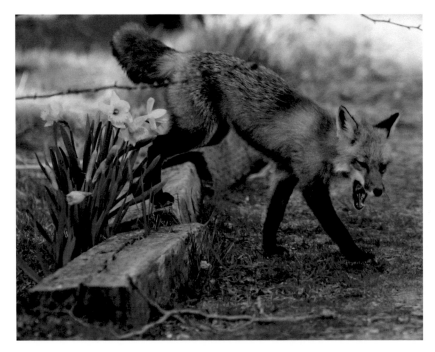 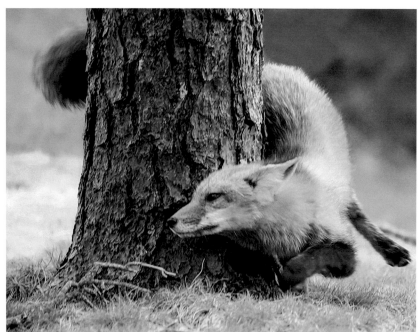

A young fox's spring dance. | OPPOSITE An eastern painted turtle at the Audubon's Wellfleet Bay Sanctuary.

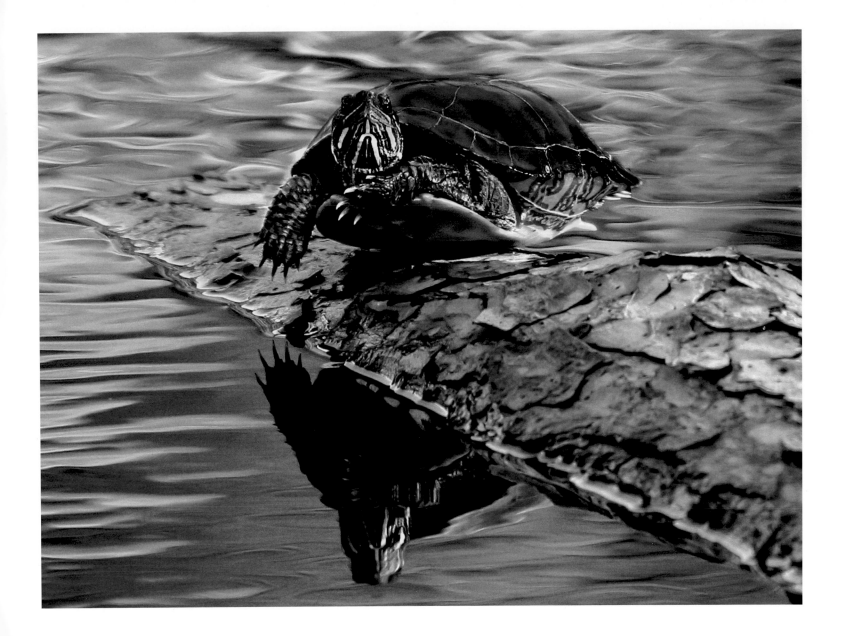

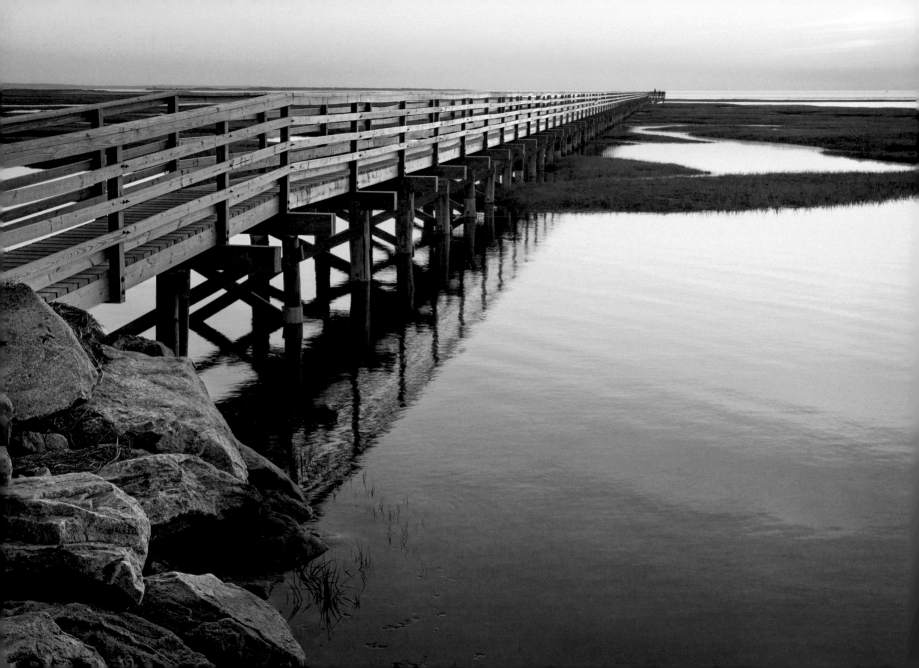

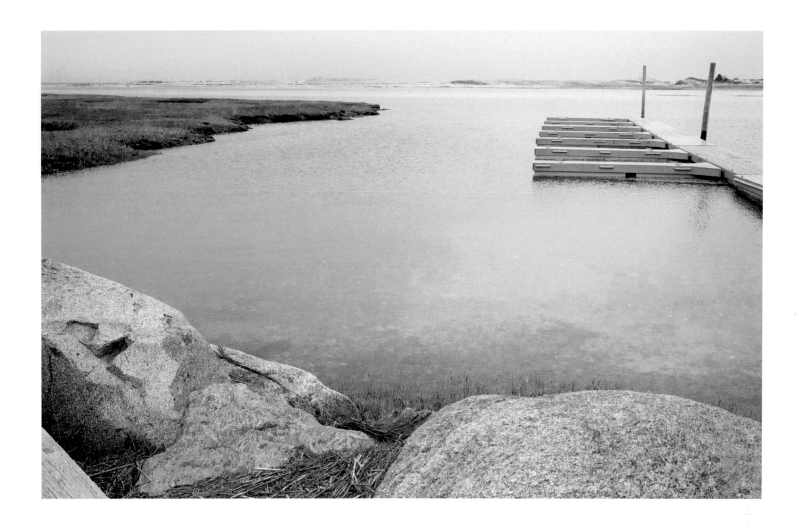

OPPOSITE Grey's Beach boardwalk, Yarmouthport. | It's still a little early for the boaters who dock at Grey's Beach, Yarmouthport.

SPRING

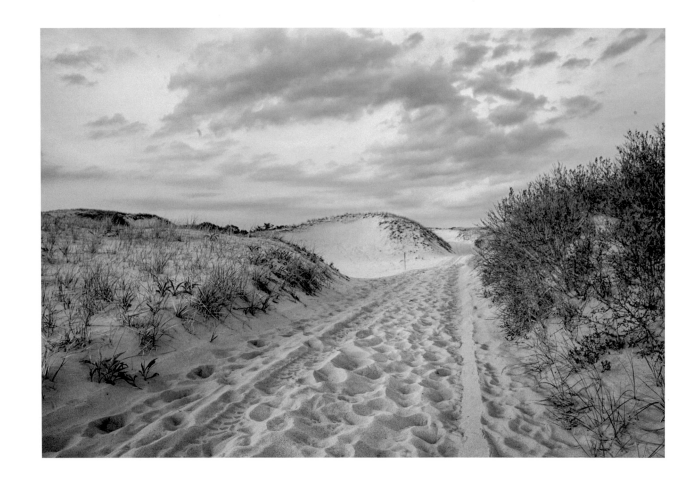

A trail through the dunes of Sandy Neck, Barnstable. | OPPOSITE Sunset over the dunes.

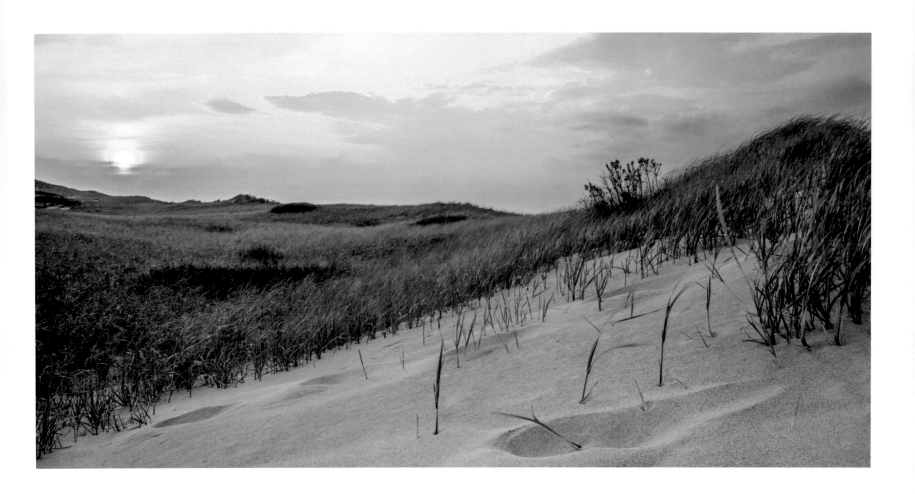

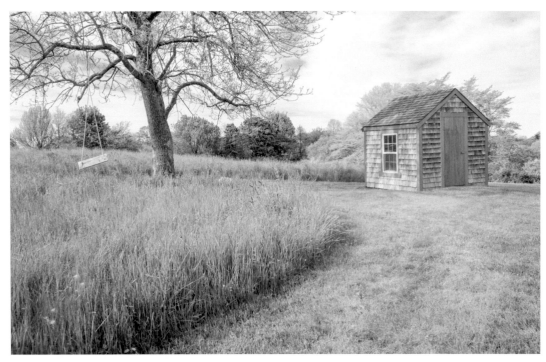

A quiet scene in Cummaquid. | RIGHT Wildflower in bloom. | OPPOSITE All's quiet at Rock Harbor in early spring.

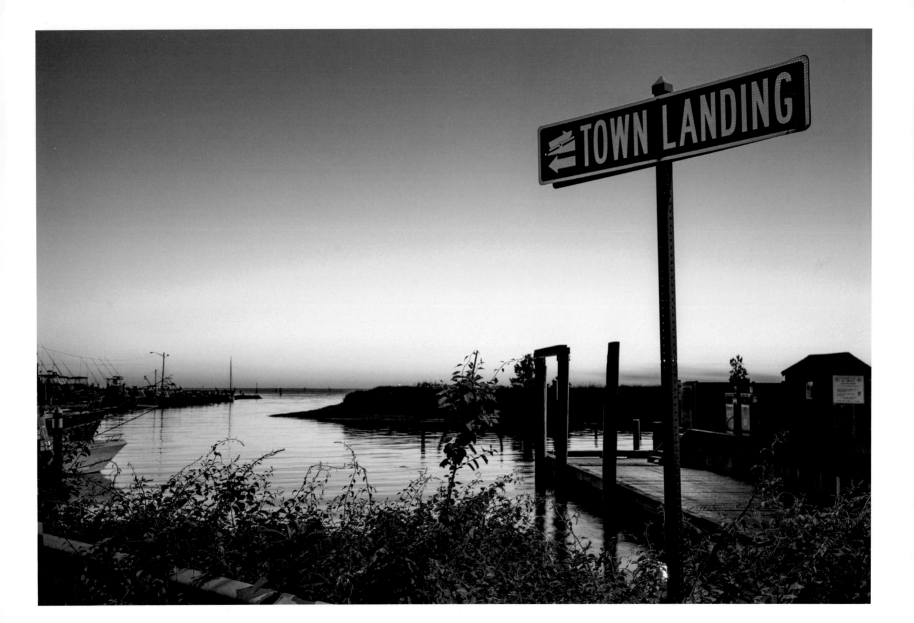

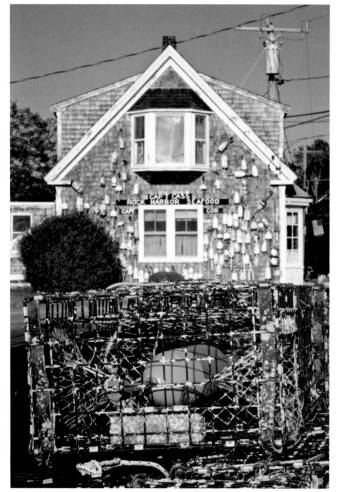

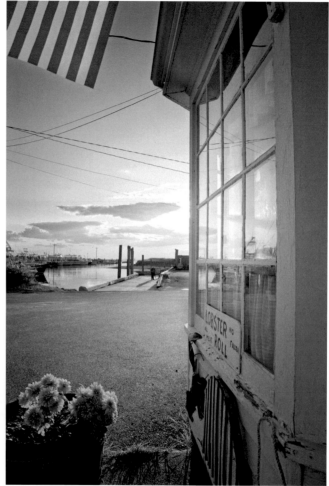

Lobsters traps ready to be set. | RIGHT The view from Captain Cass's. |
OPPOSITE Late afternoon sun catches the stern of a dinghy at Hemenway Landing, Eastham.

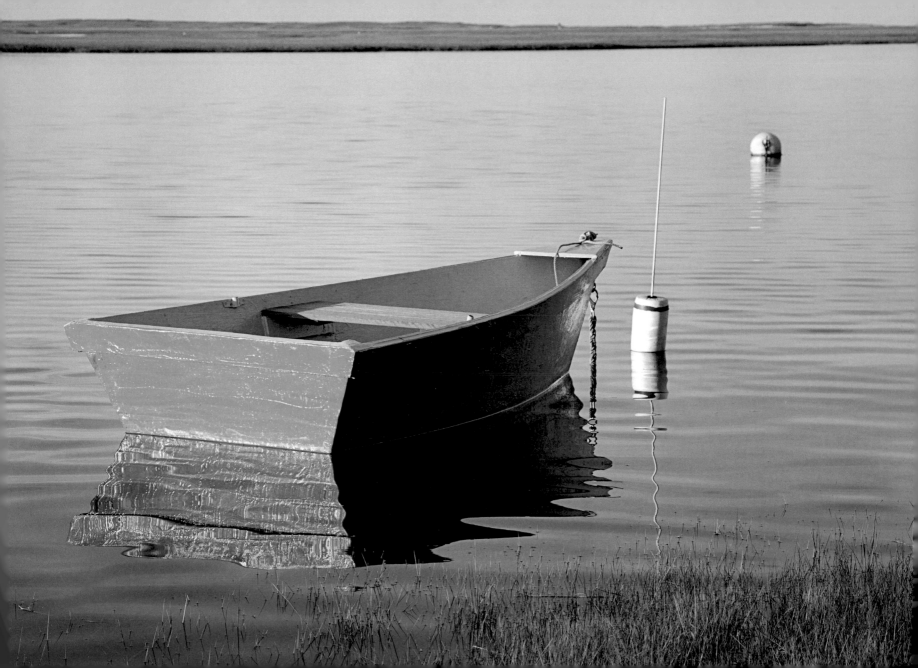

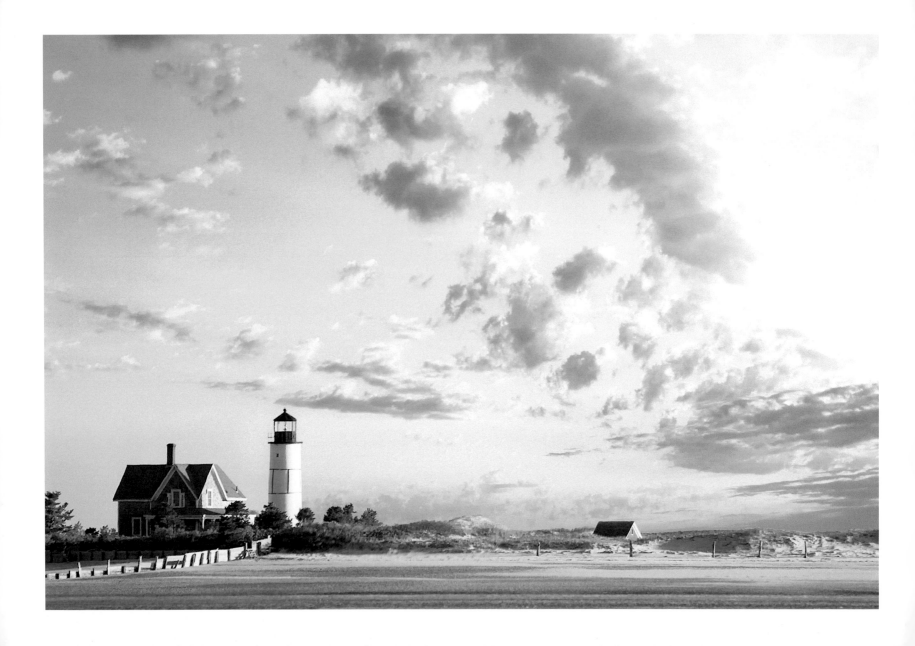

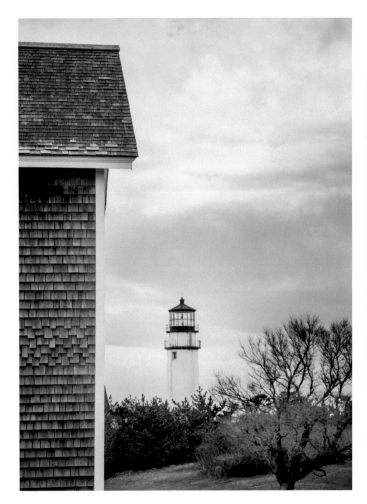

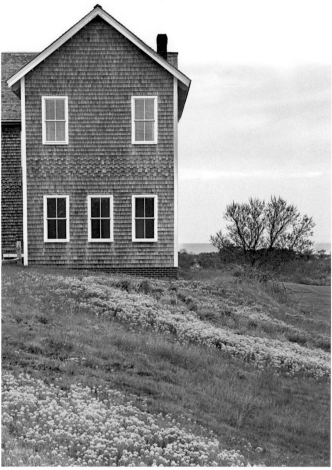

OPPOSITE Sandy Neck Light, Barnstable. |
Highland Light, Truro. | RIGHT The old Highland House hotel, near Highland Light, is now home to the Highland House Museum.

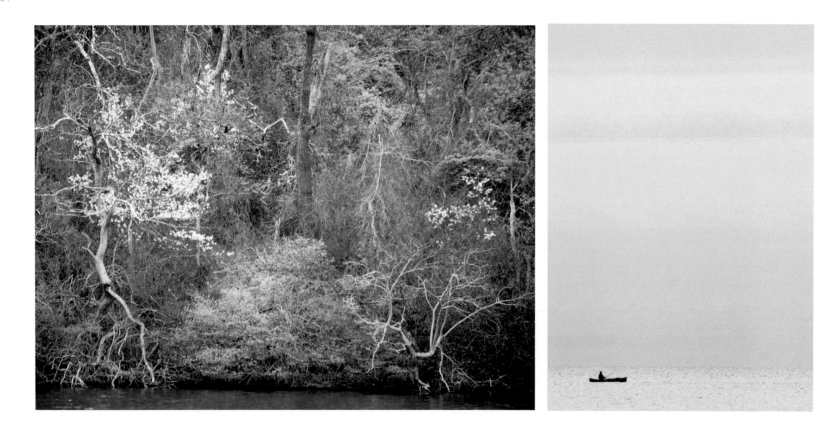

Spring buds in the Orleans conservation lands. | RIGHT A view toward Pleasant Bay. | OPPOSITE The Orleans spit across Nauset Marsh.

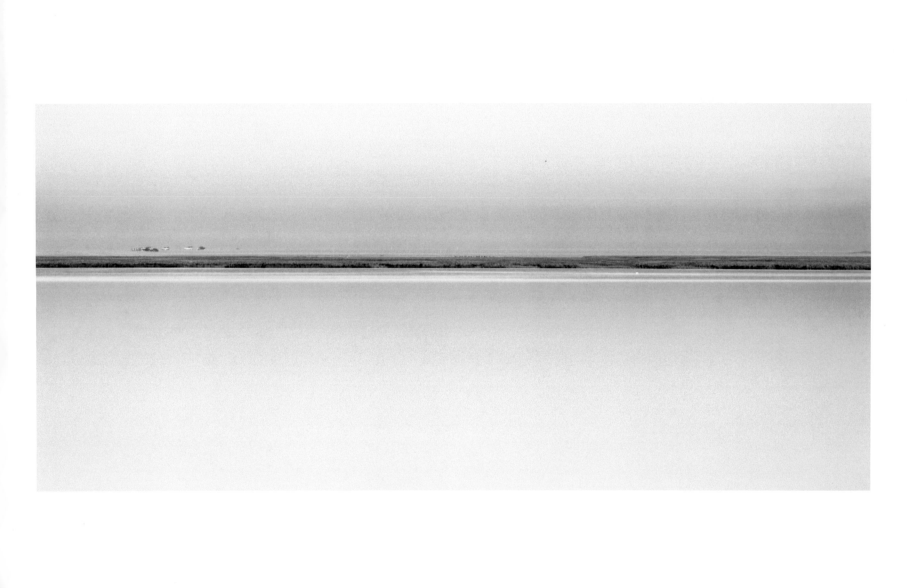

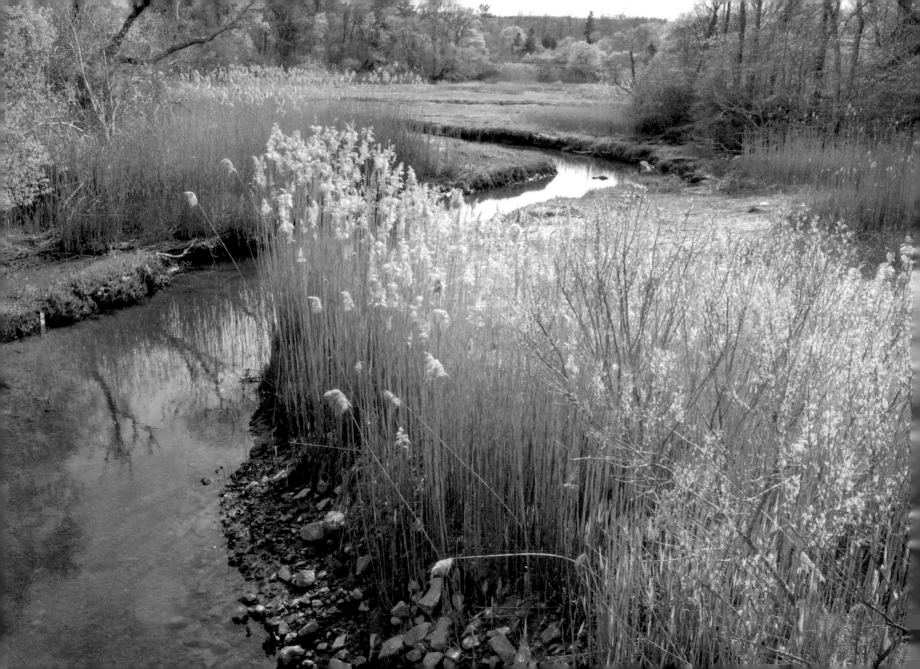

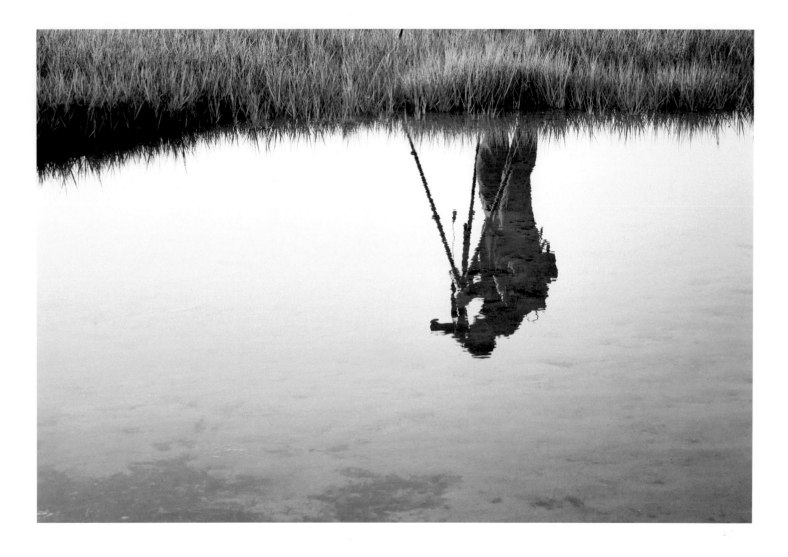

OPPOSITE East Sandwich Game Farm. | Photographer at work.

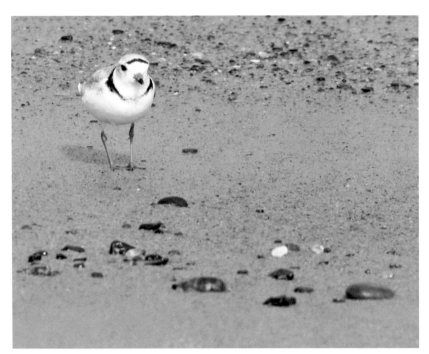 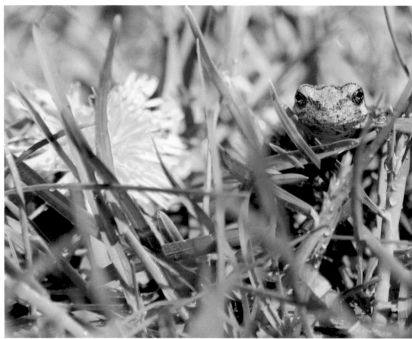

Piping plovers return to the Cape in spring and settle in for the summer. | RIGHT Dandelion and toad. |
OPPOSITE Each spring gulls feast on herring as they make their annual run upstream.

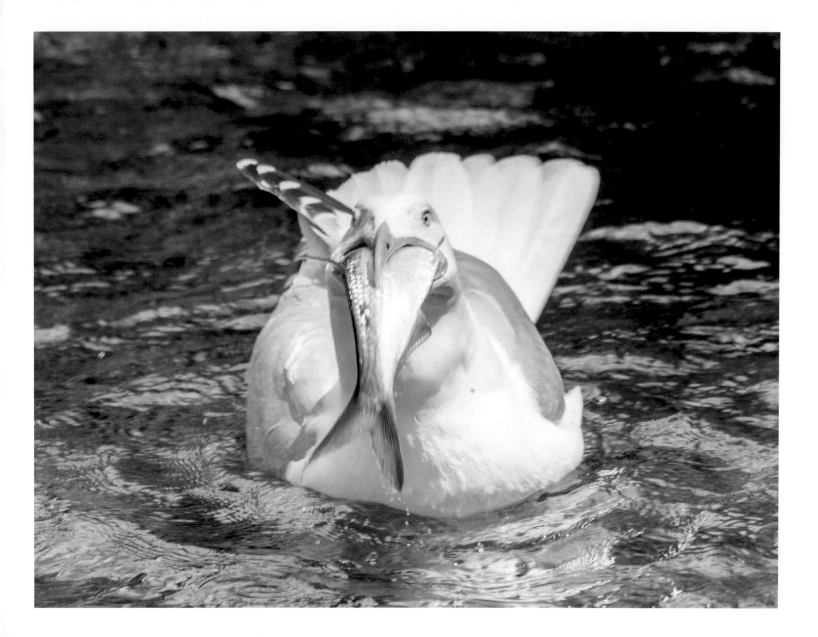

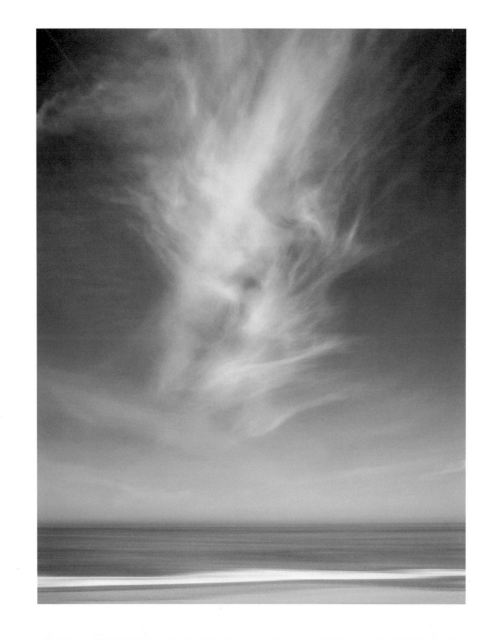

Partly cloudy. |
OPPOSITE The marinas start to fill up in late spring.

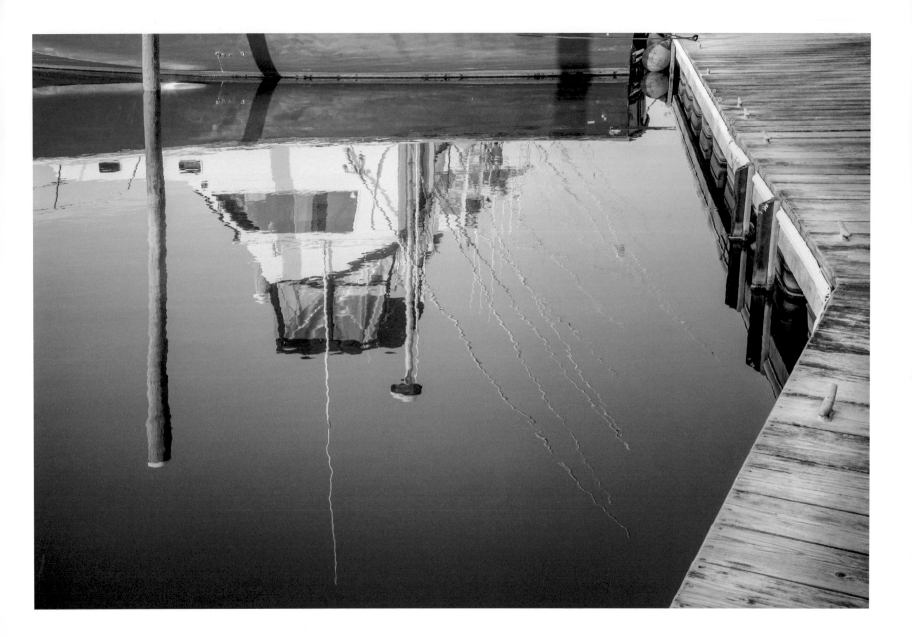

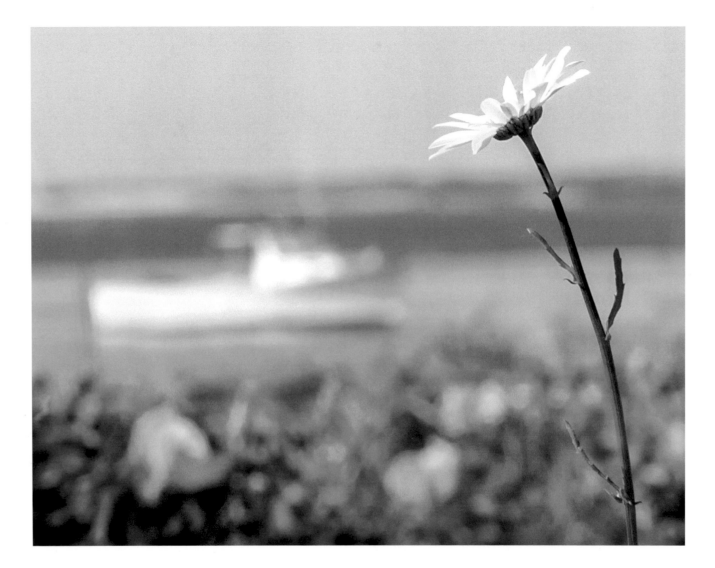

Priscilla Landing, Orleans. |
OPPOSITE Rosa rugosa, which covers dunes all over Cape Cod, is actually an invasive species imported from Asia in the nineteenth century.

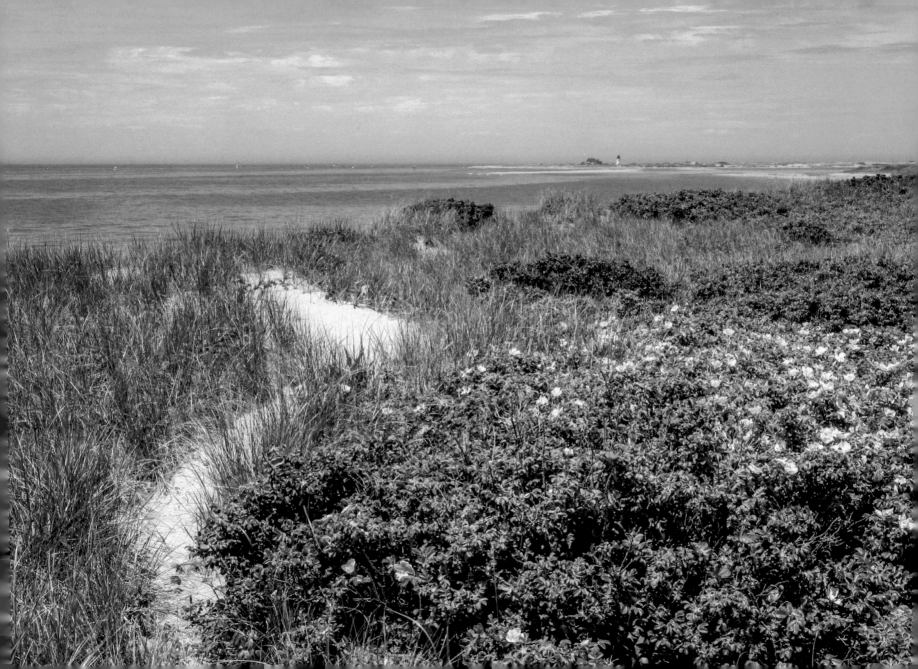

SUMMER

"Summertime
and the living is easy..."
–from "Summertime" by
George and Ira Gershwin

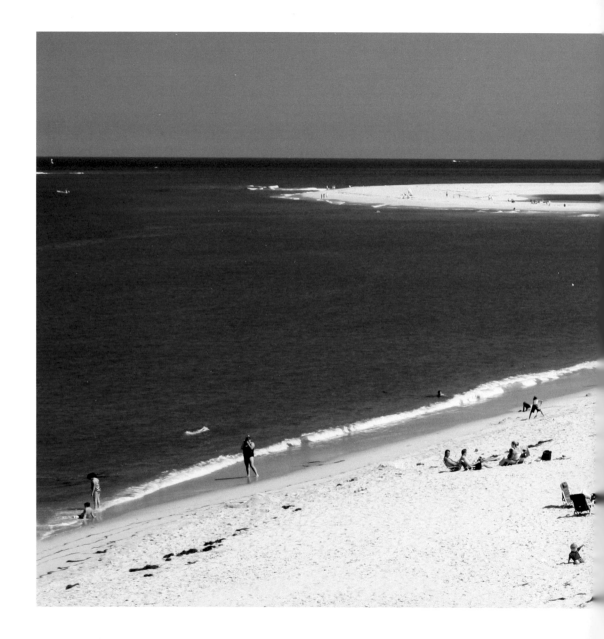

Summer crowds at Chatham's Lighthouse Beach.

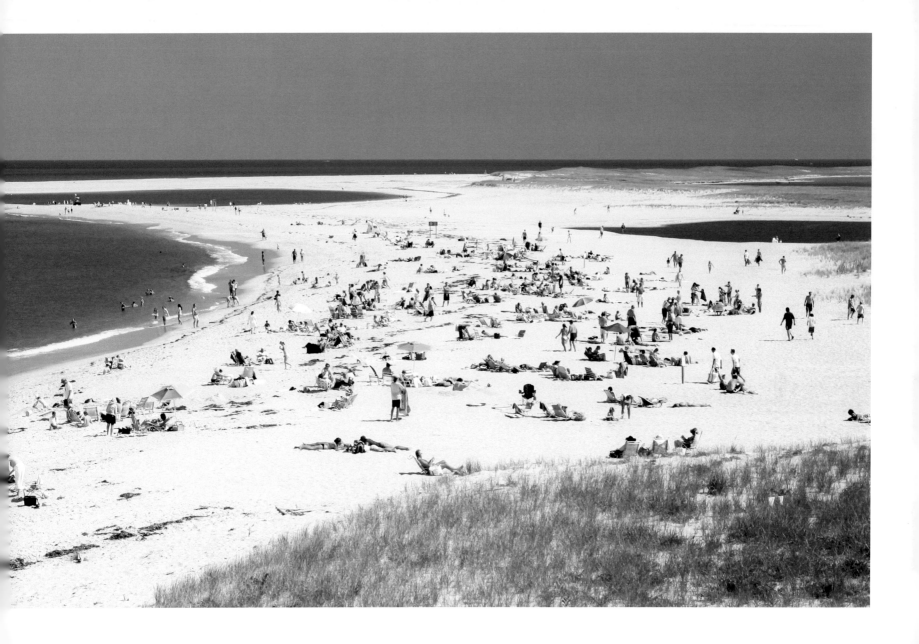

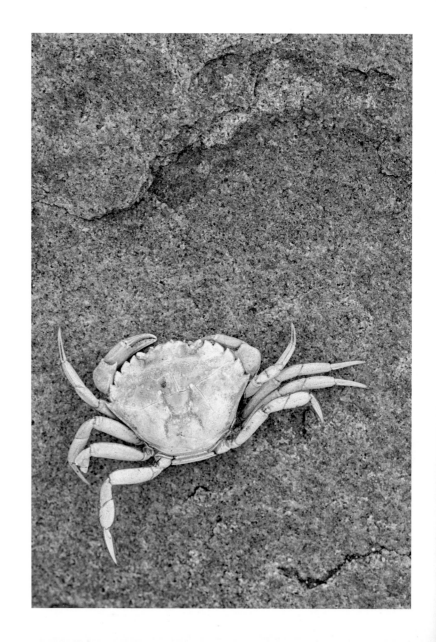

Still life with crab shell. | OPPOSITE Summer wave.

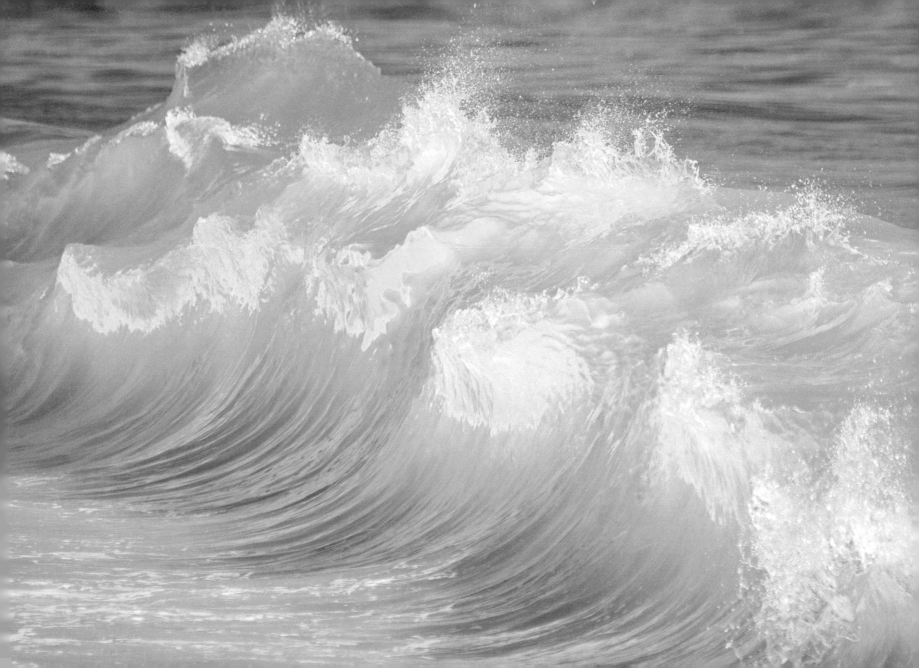

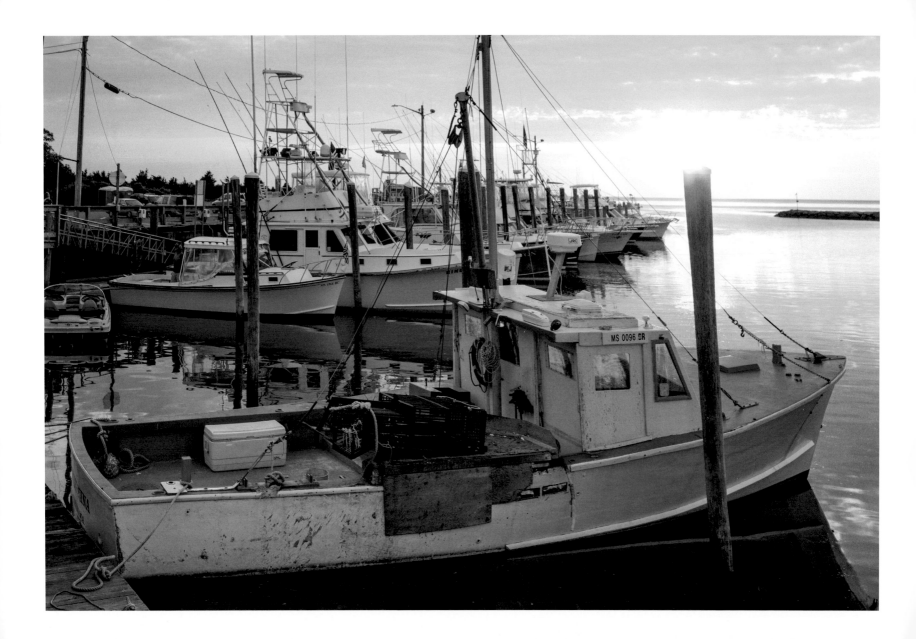

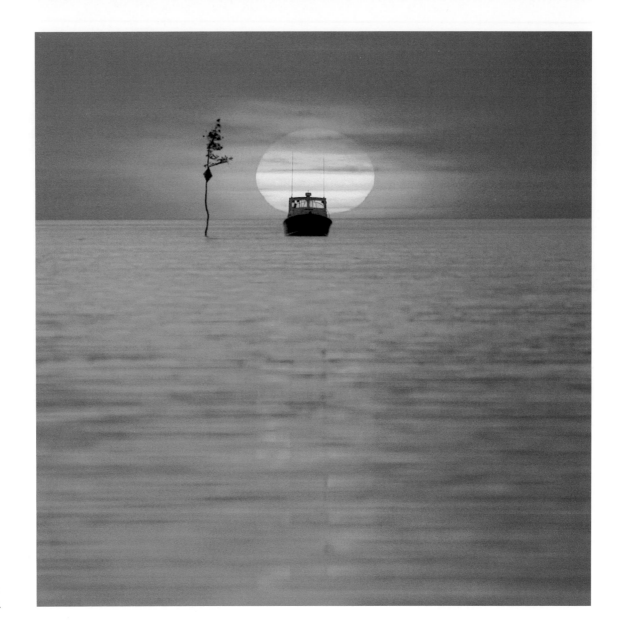

OPPOSITE The Rock Harbor fishing
fleet at sunset. | A fishing boat heads
home as the sun sets over Rock Harbor.

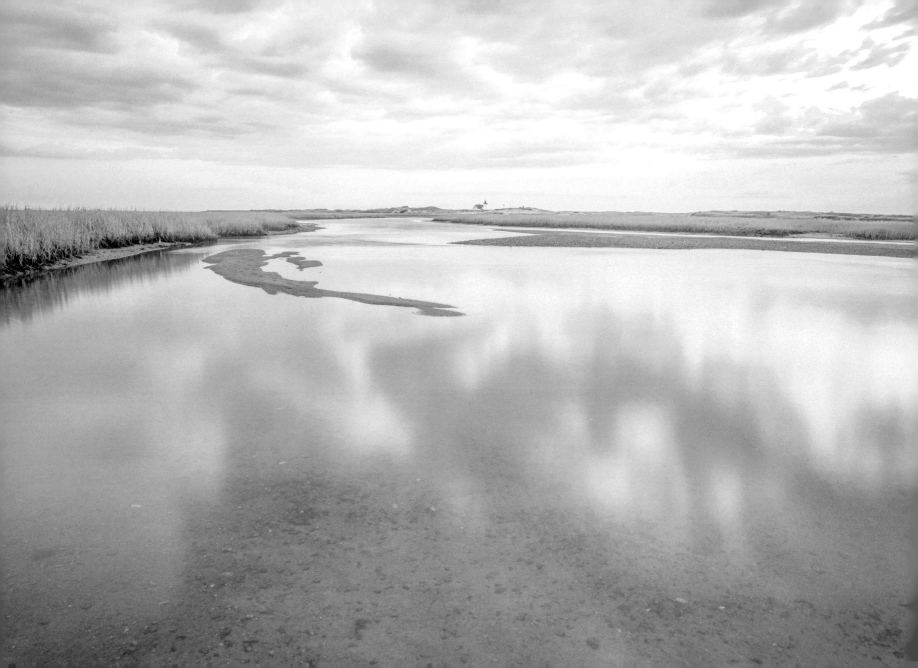

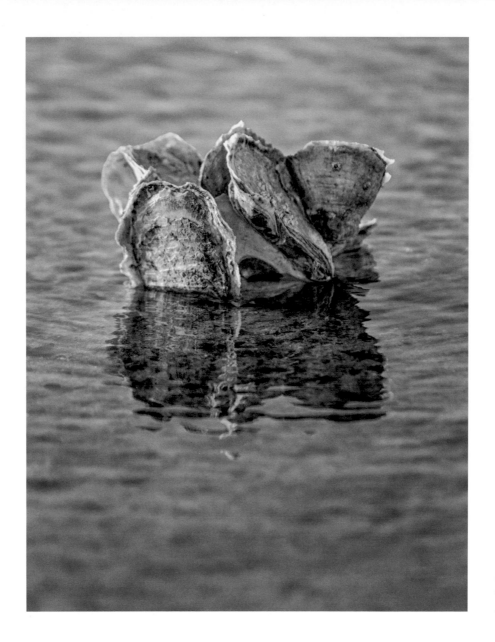

OPPOSITE Hatches Harbor looking
toward Race Point, Provincetown. |
A cluster of oyster shells.

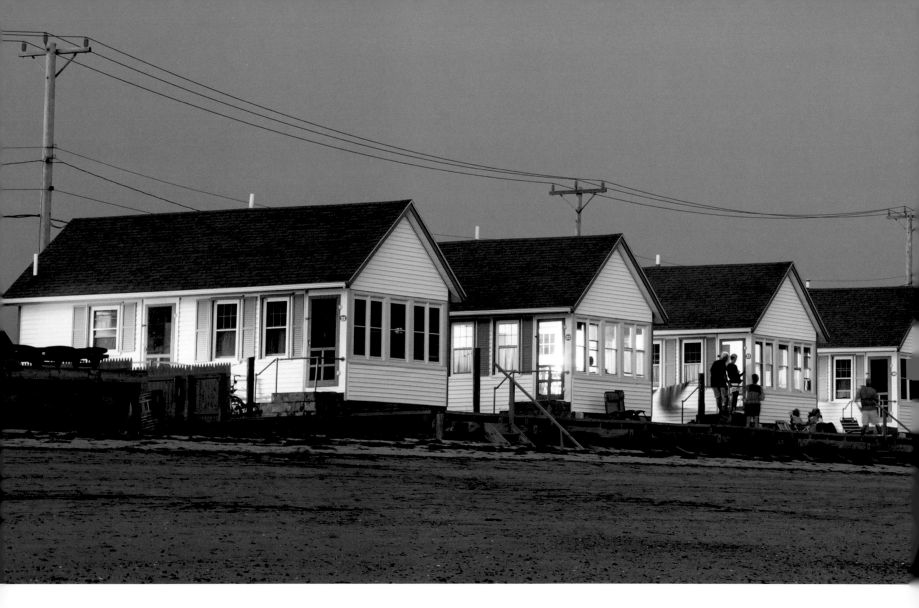

Cottages on Cape Cod Bay, Truro.

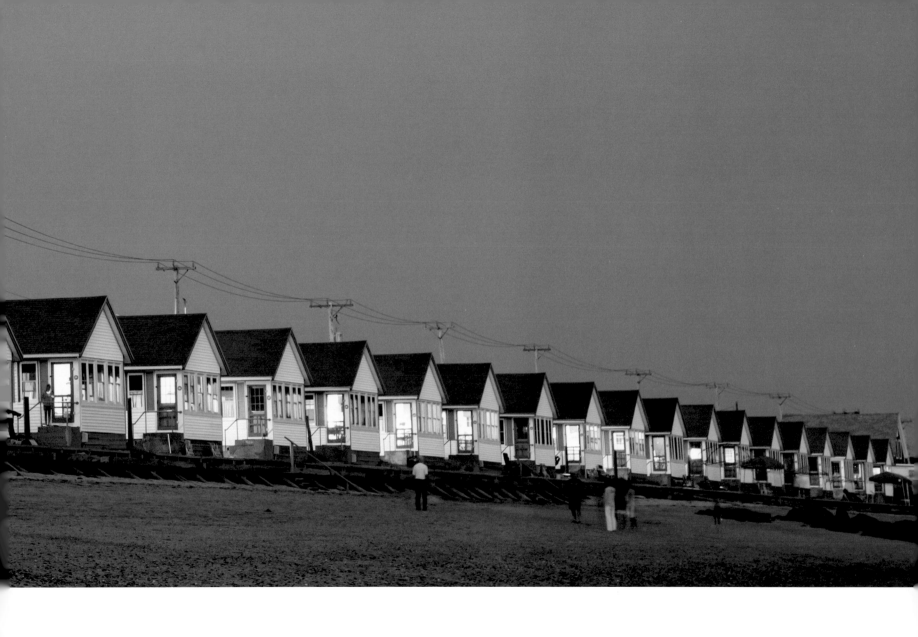

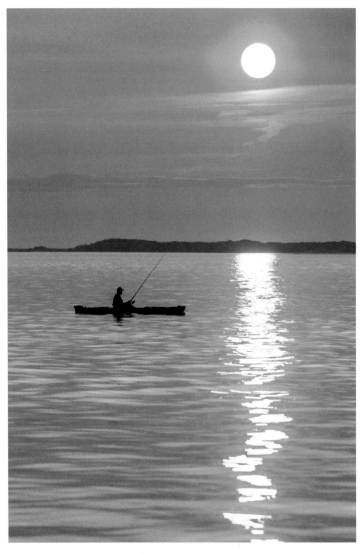

A kayak fisherman at sunset on Barnstable Harbor. | RIGHT The lighthouse and cottages at Sandy Neck, Barnstable.

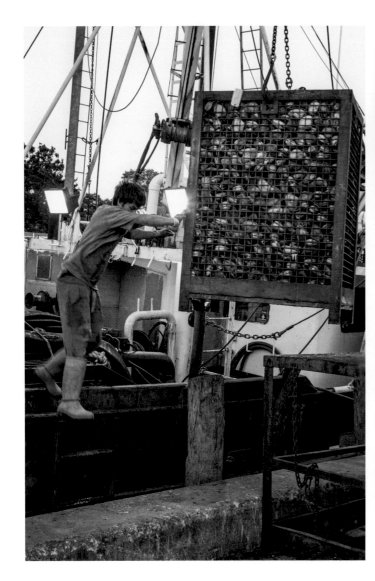

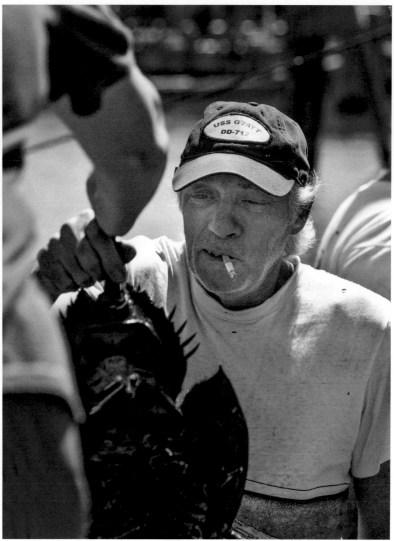

Commercial clammers return with their haul at Hyannis Harbor. | RIGHT Horseshoe crabs are harvested for medical products.

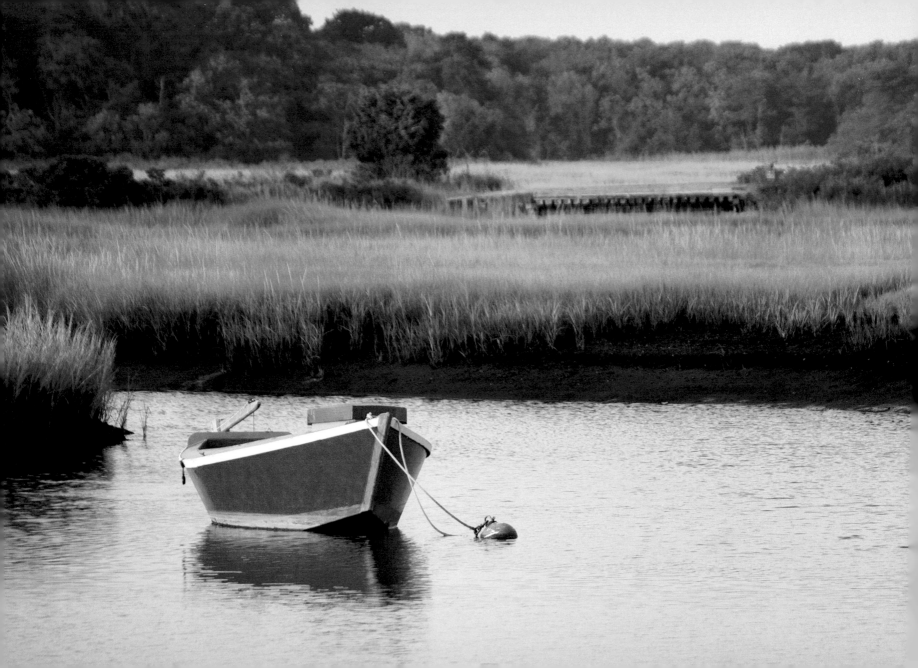

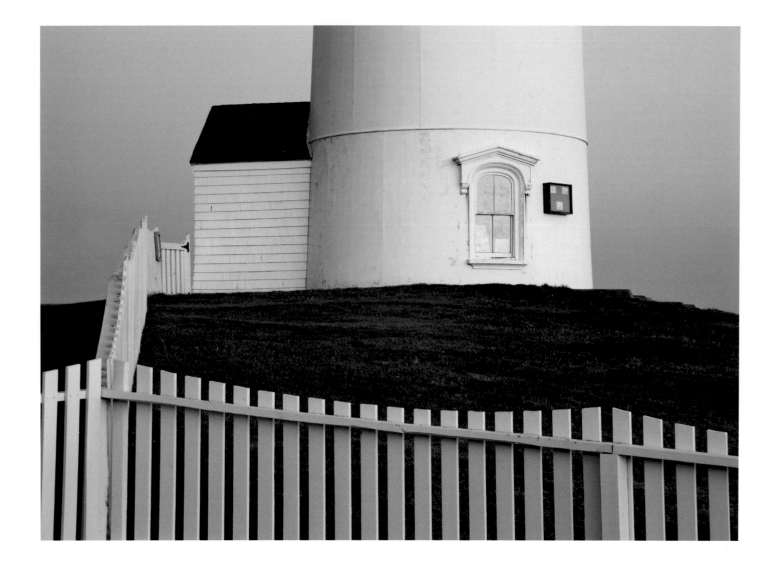

OPPOSITE Red boat on the Herring River, Route 28, Harwich. | Twilight at Nobska Light, Woods Hole.

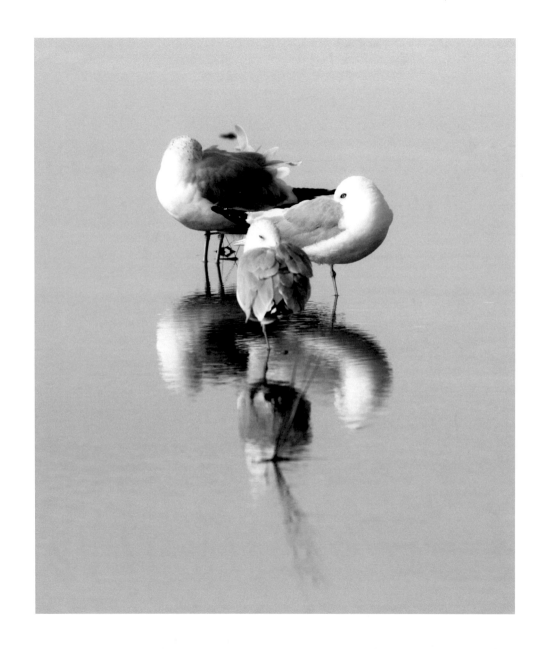

Gulls in formation. |
OPPOSITE Open wide! A humpback whale displays its baleen.

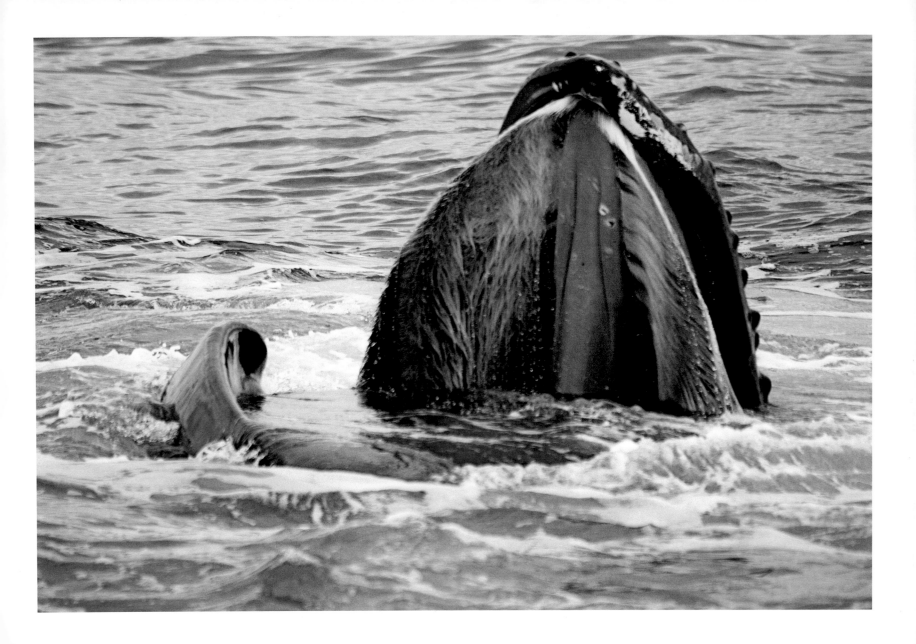

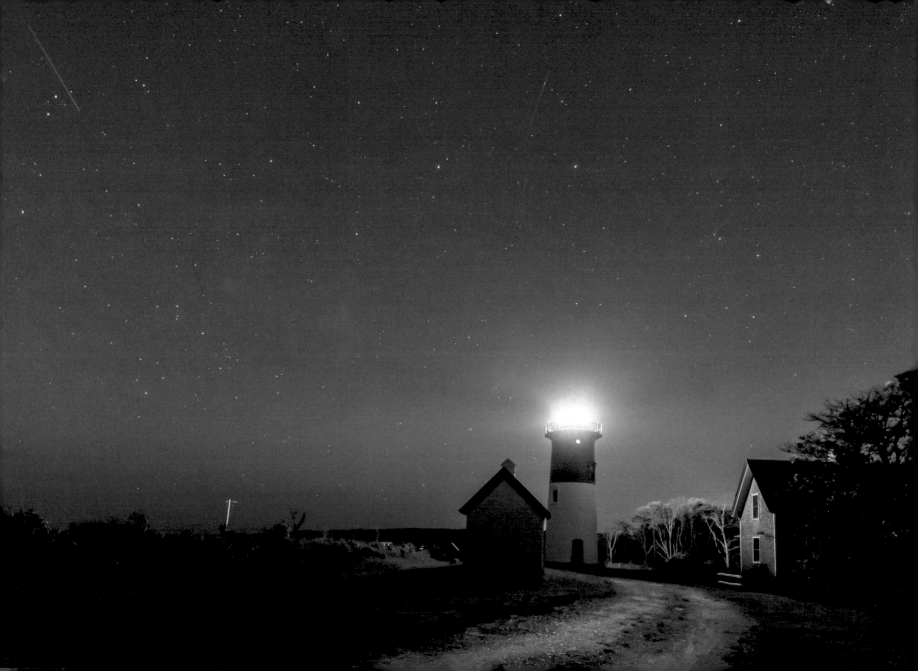

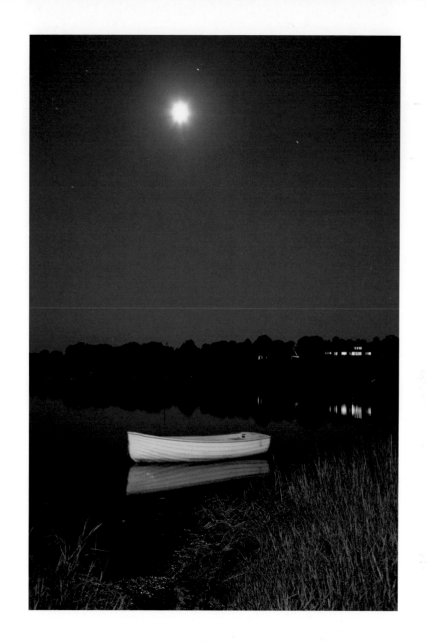

OPPOSITE Nauset Light at night. | A quiet evening
on Mill Pond, Chatham.

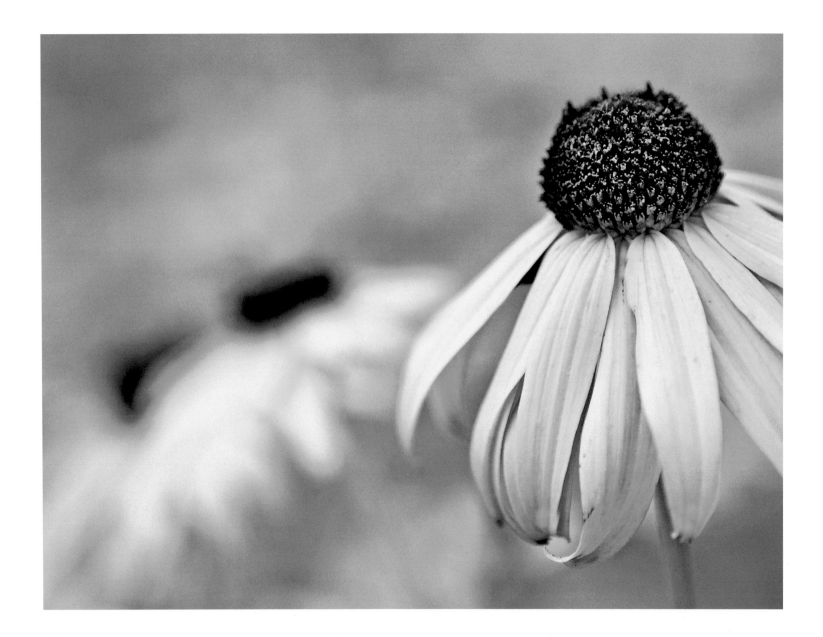

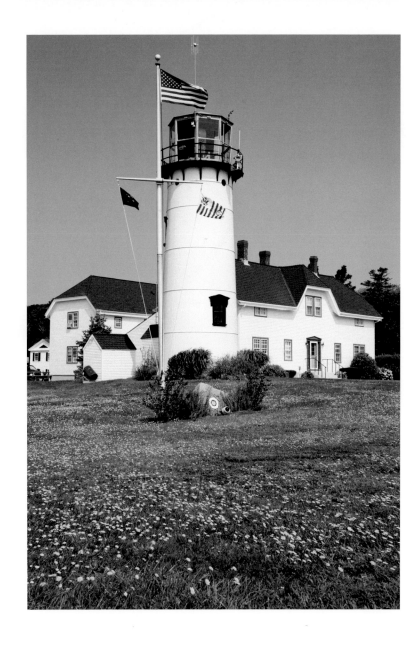

OPPOSITE Black-eyed Susans grow wild on the Cape. | Chatham Lighthouse.

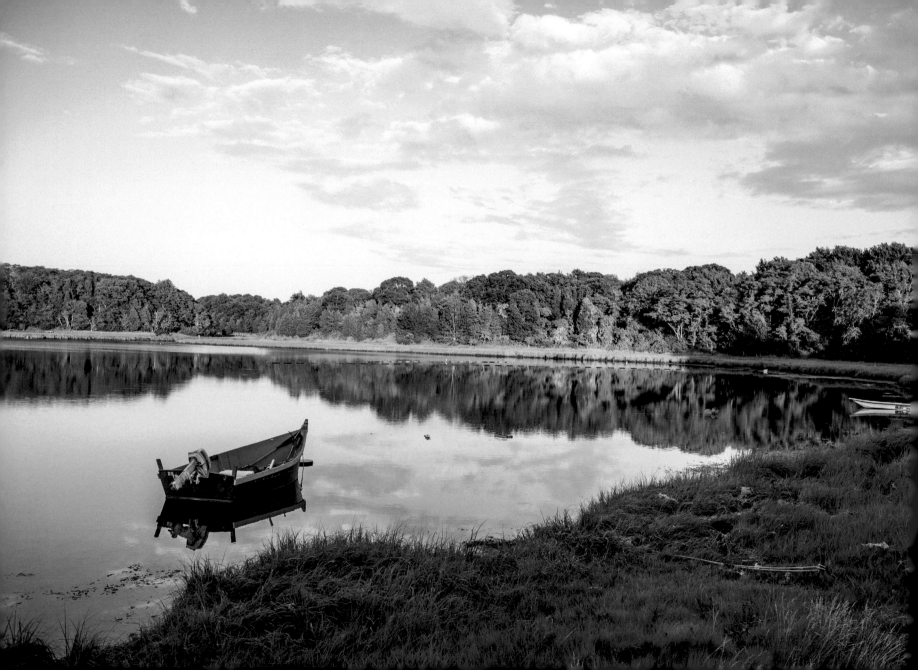

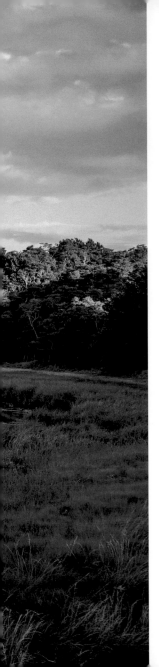

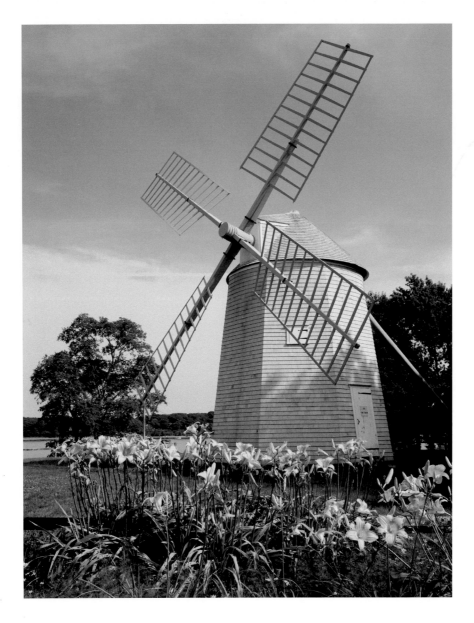

OPPOSITE Salt Pond, Eastham. |
Windmill Park, Orleans.

Kayaks at rest. | OPPOSITE Fireworks on the Beach.

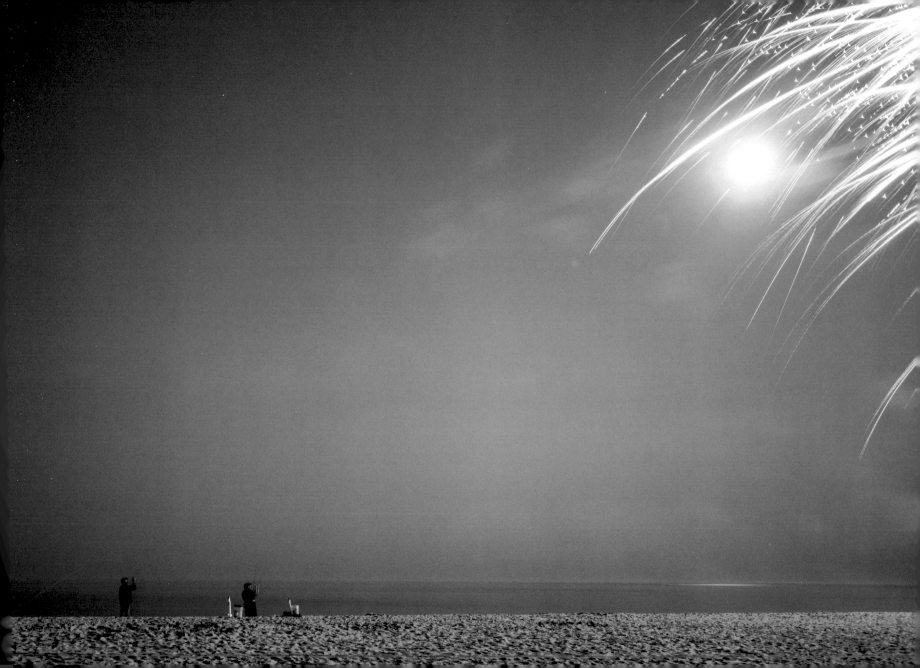

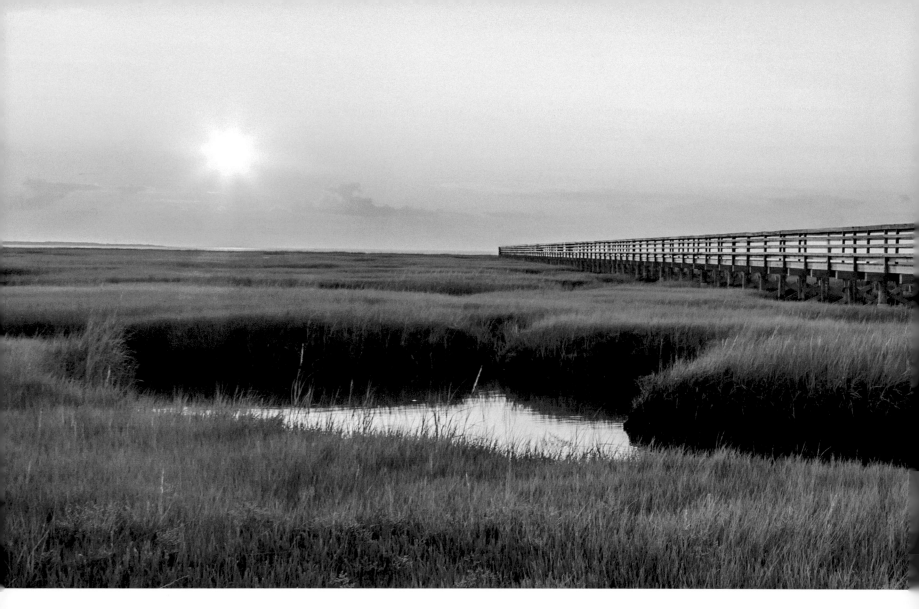

Grey's Beach boardwalk at sunset.

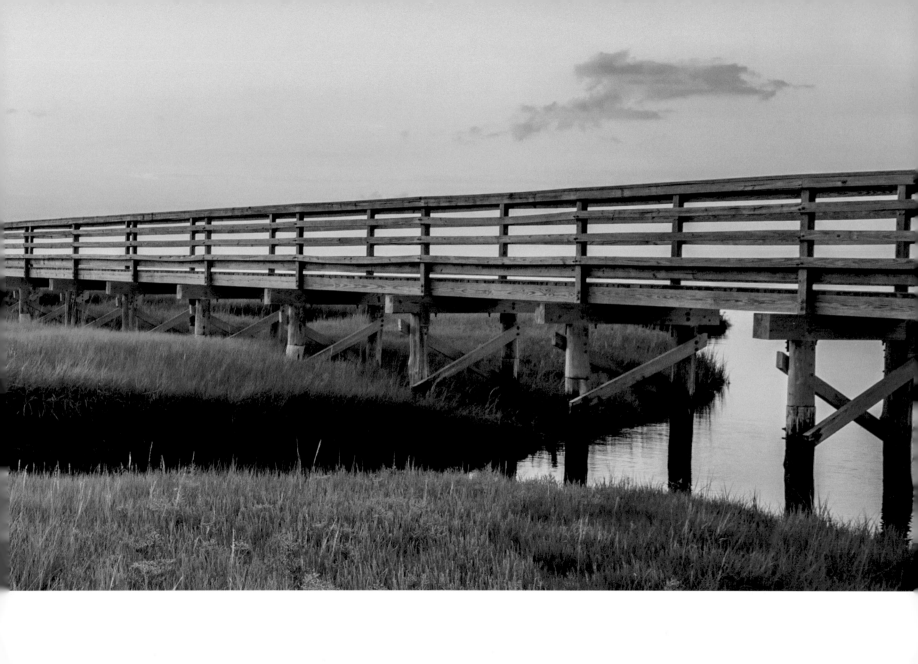

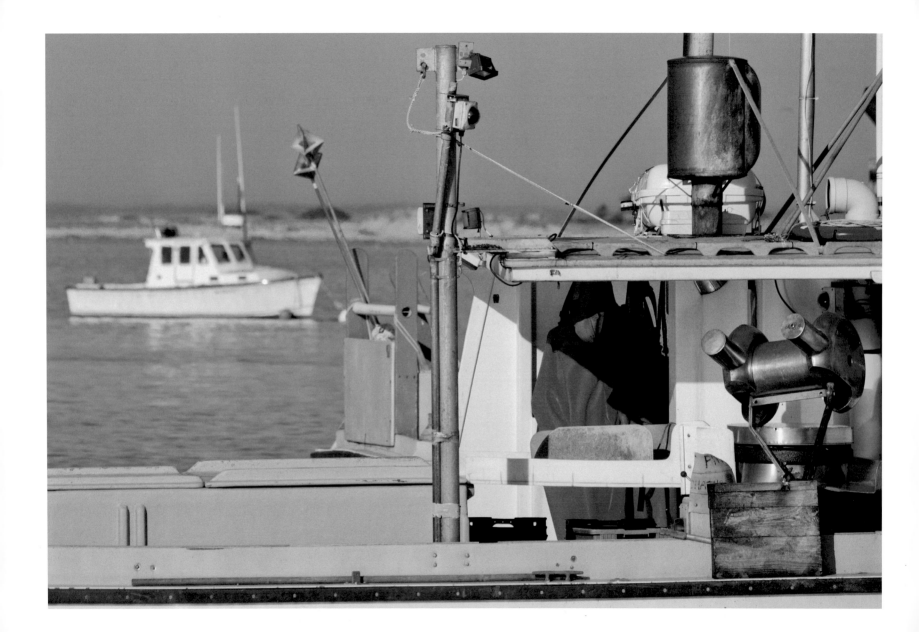

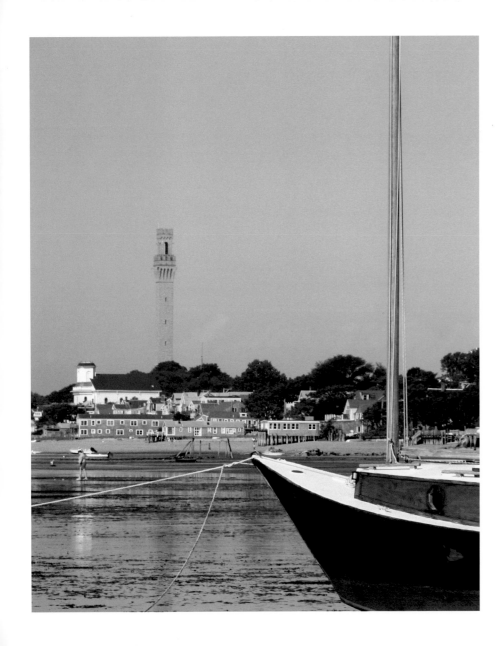

OPPOSITE Fishing boats in Chatham Harbor. |
Provincetown's Pilgrim Monument.

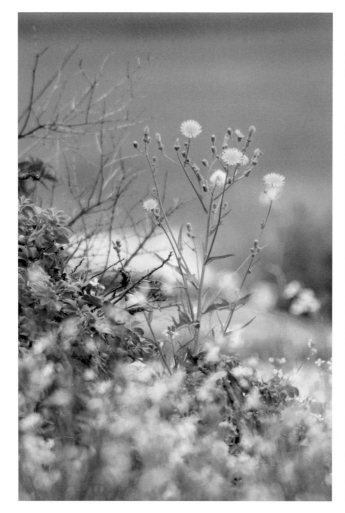

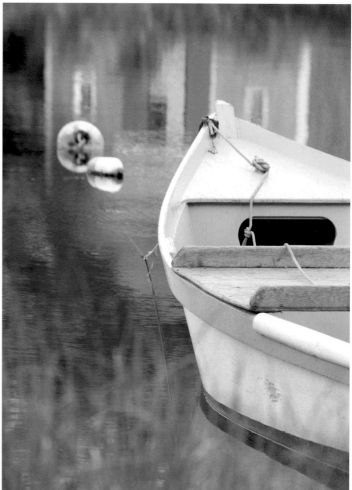

Wild flowers at Hemenway Landing, Eastham. | RIGHT Packet Landing, Orleans.

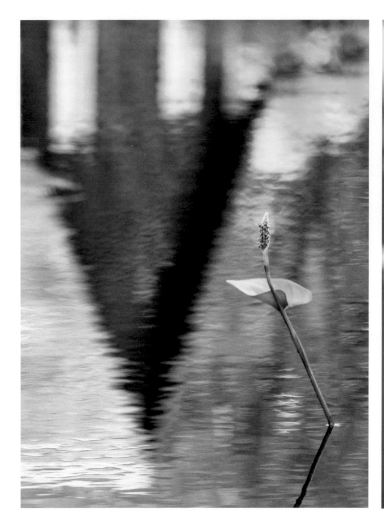
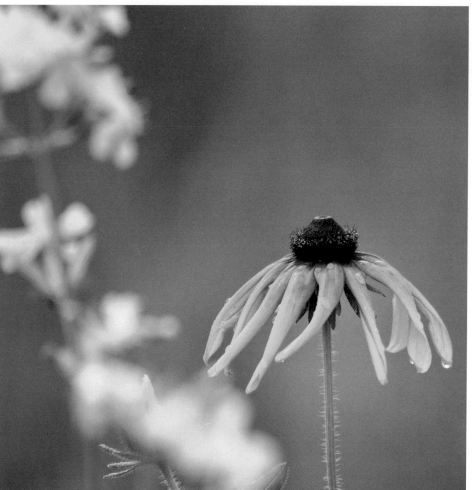

Stony Brook Mill, Brewster. | RIGHT Summer flowers after rain.

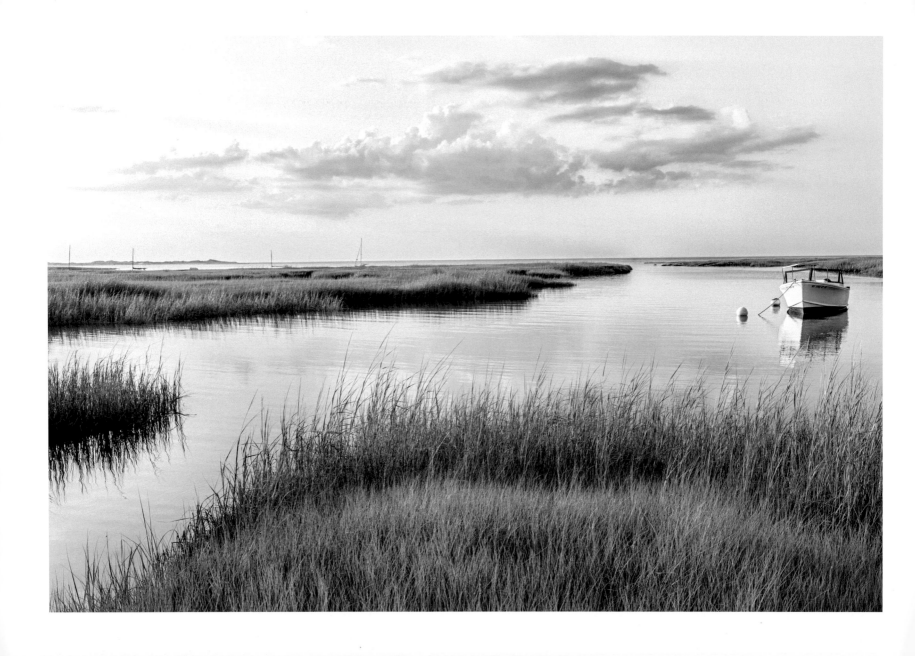

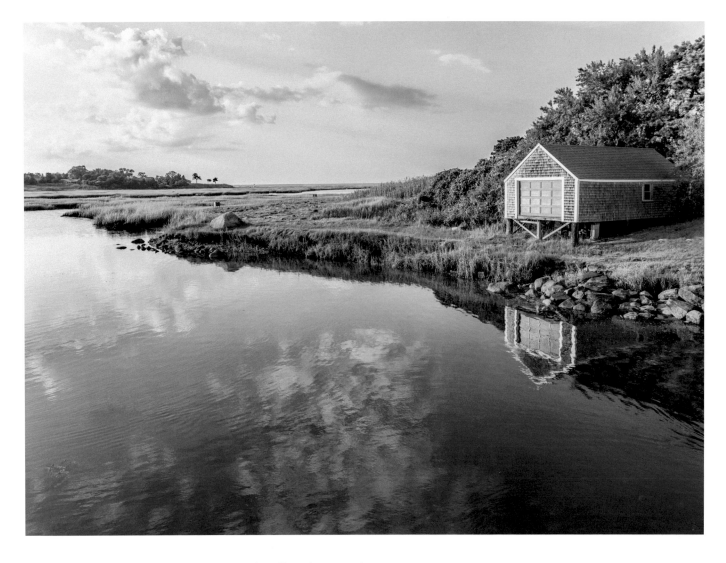

OPPOSITE Short Wharf Creek, Yarmouthport. | Mill Creek, Yarmouthport.

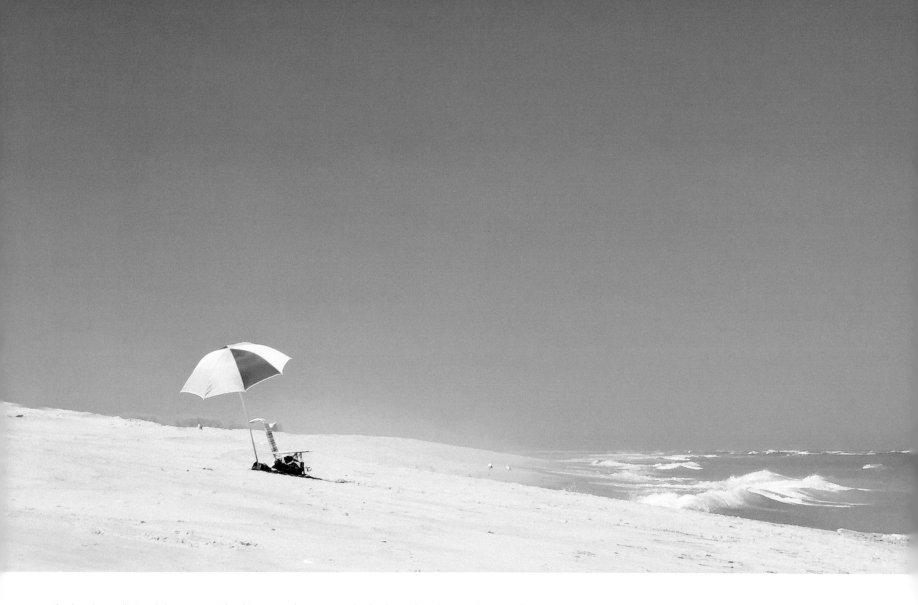

Chatham's North Beach became an island in 2007 when a storm broke through and created a new inlet. During summer, a water taxi ferries people out to the isolated beach.

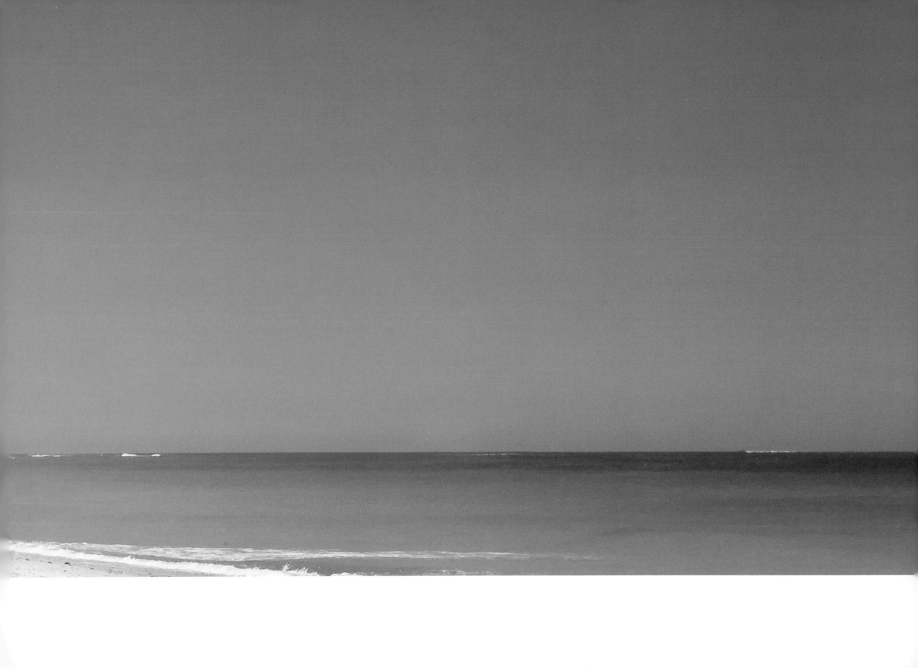

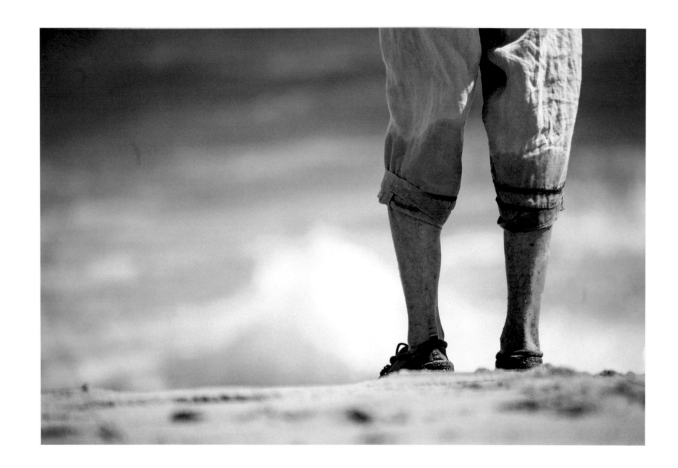

Purple shoes on the beach. | OPPOSITE Kite surfing on Wellfleet Harbor.

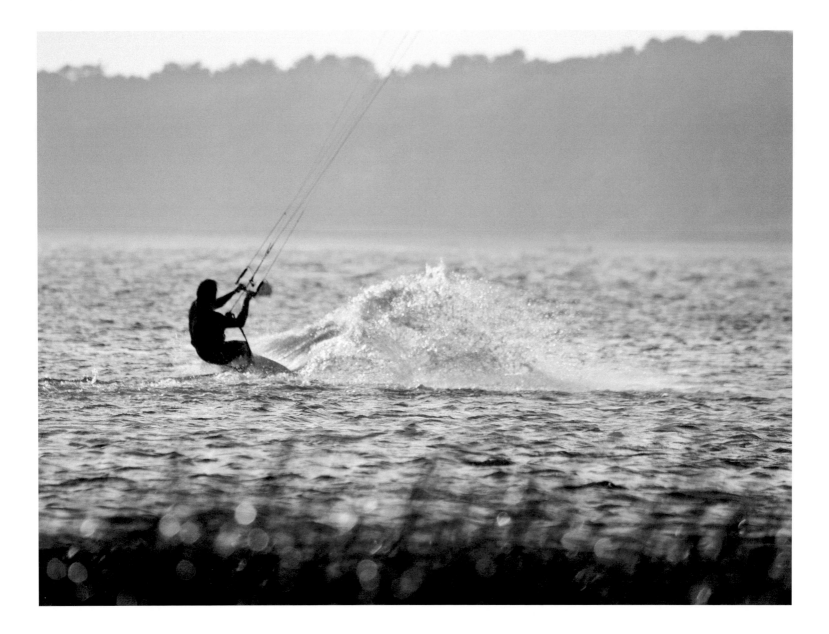

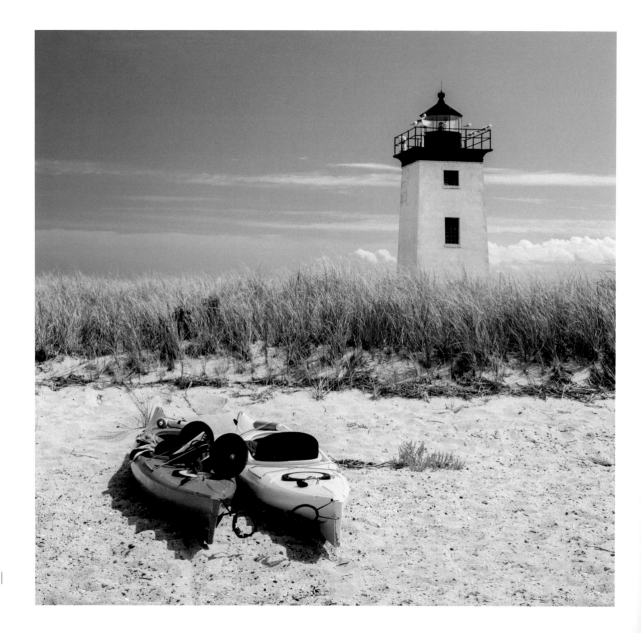

Longpoint Lighthouse at the tip of Cape Cod. |

OPPOSITE A willet in flight.

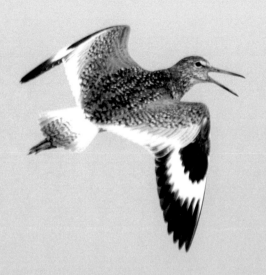

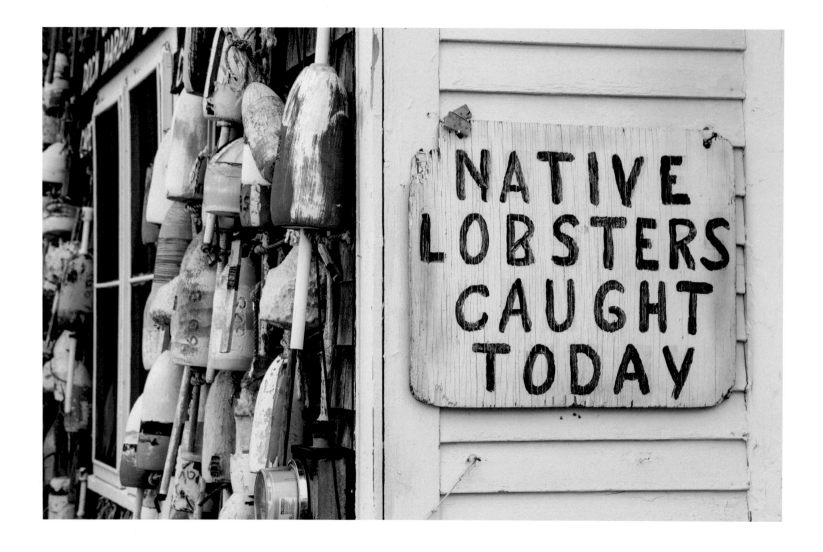

Can't get much fresher than that. | OPPOSITE After the lobster bake.

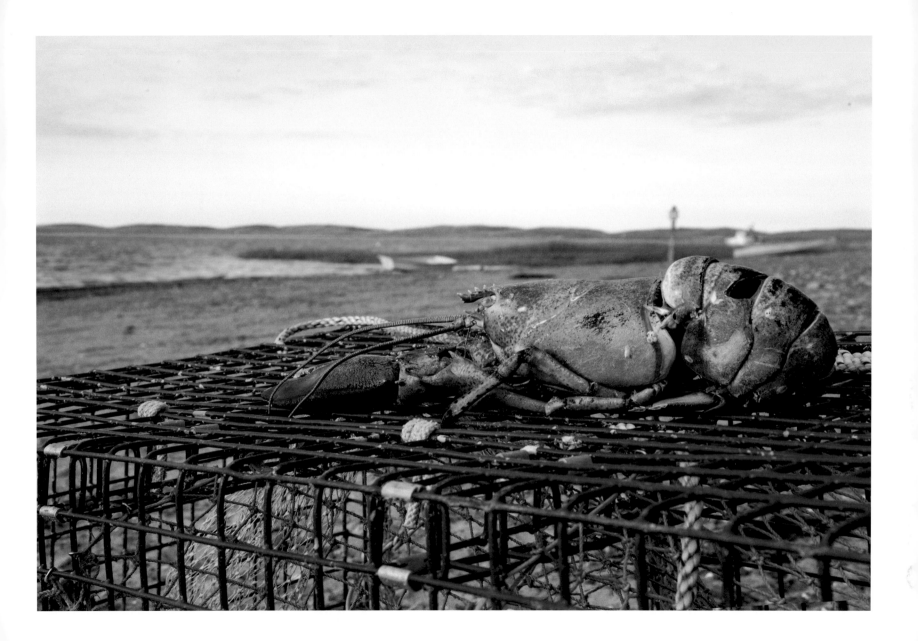

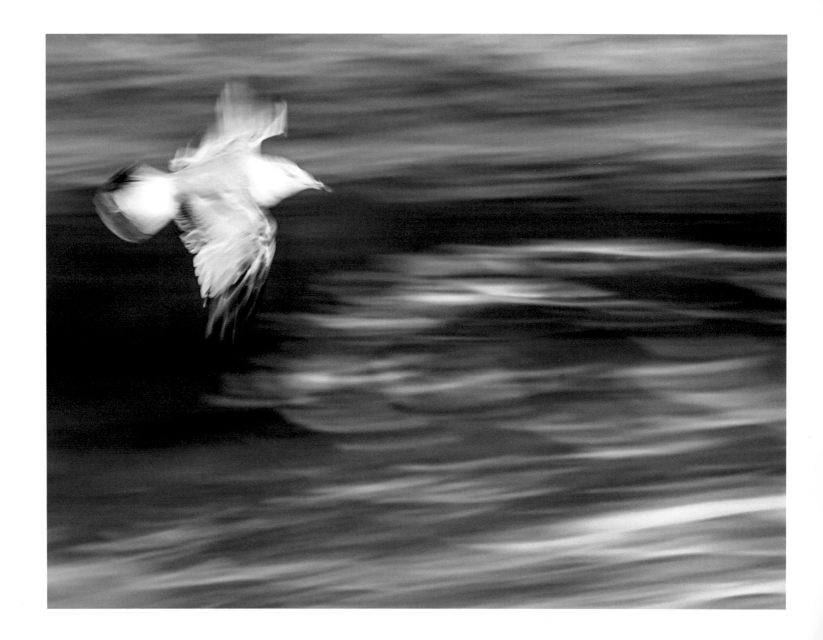

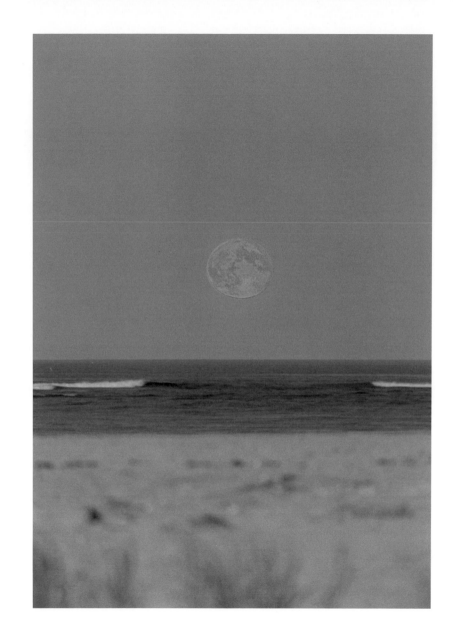

OPPOSITE Panning of gull in flight. |
Moonrise over Chatham inlet.

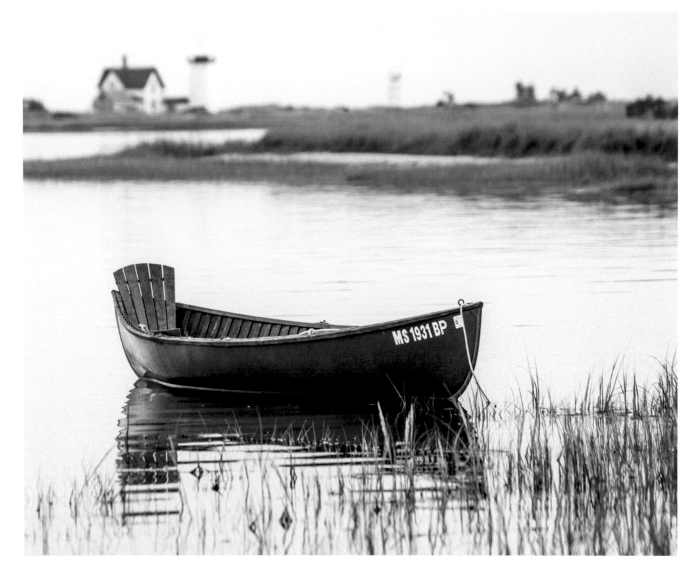

Stage Harbor, Chatham. | OPPOSITE Summer storm clouds move in over Rock Harbor, Orleans.

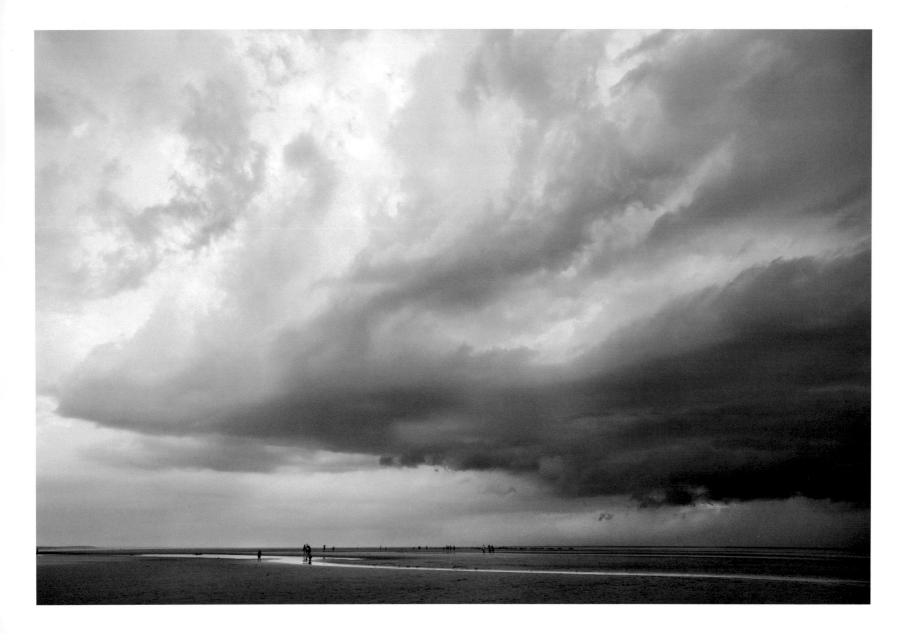

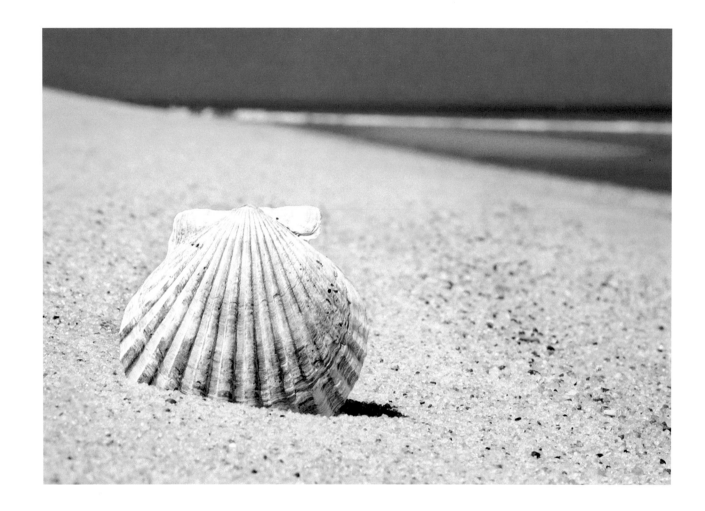

Scallop shell washed up on ocean beach. | OPPOSITE Low tide on the Brewster flats.

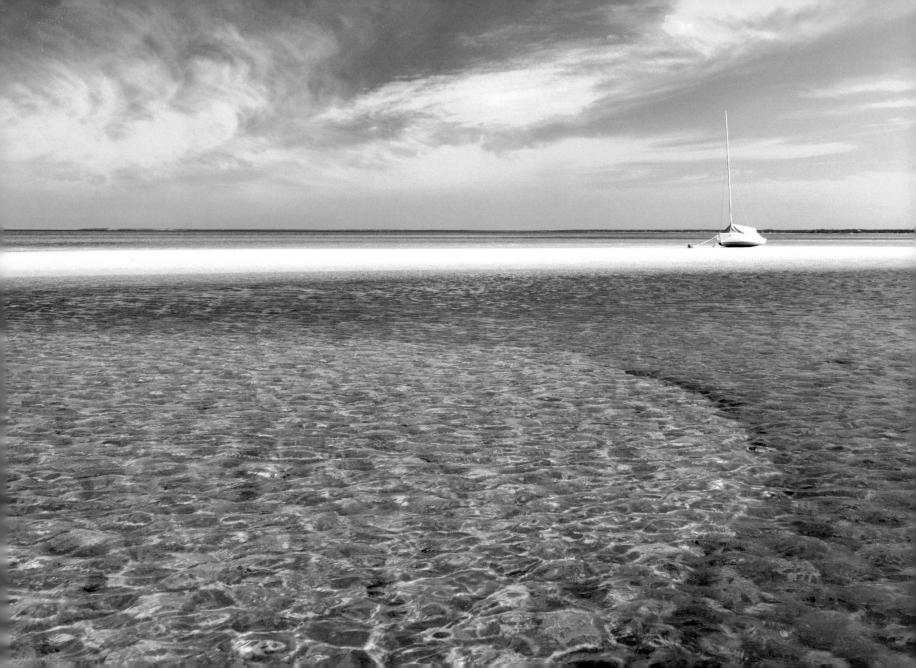

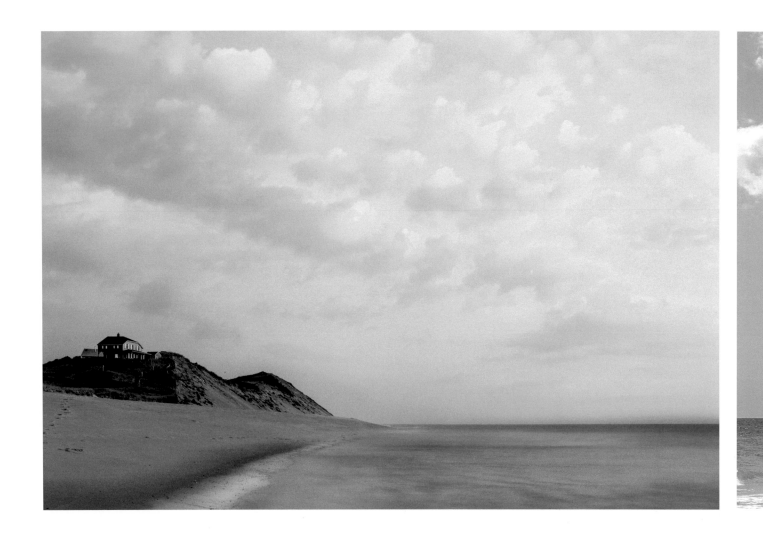

Sunrise at Ballston Beach, Truro. | OPPOSITE Coast Guard Beach, Eastham.

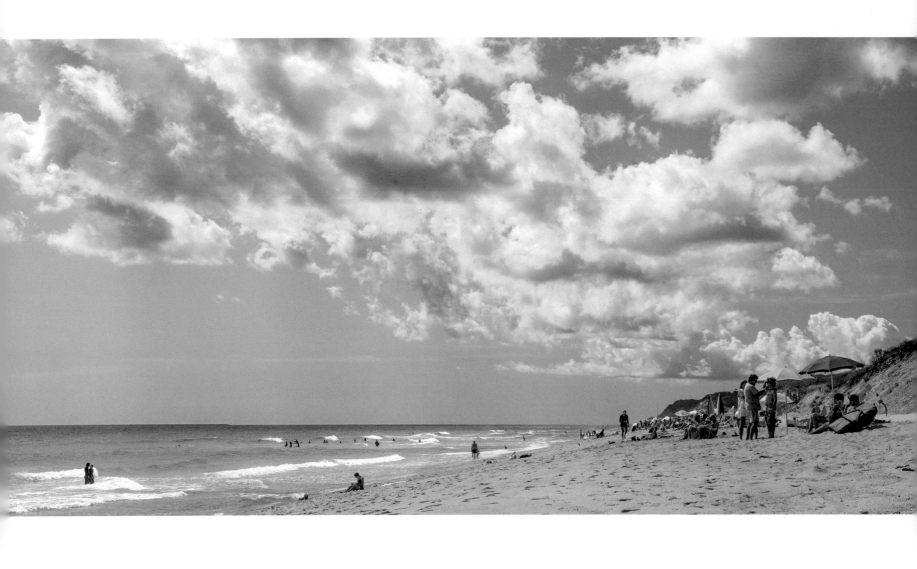

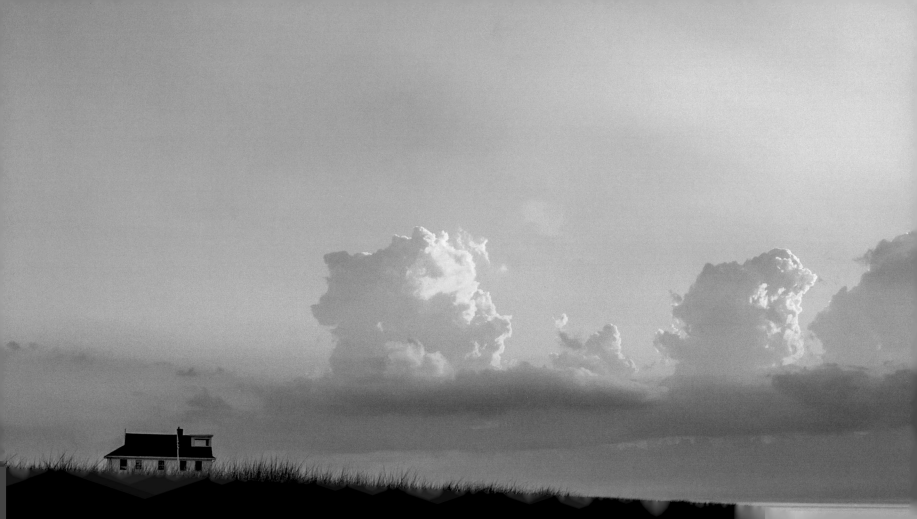

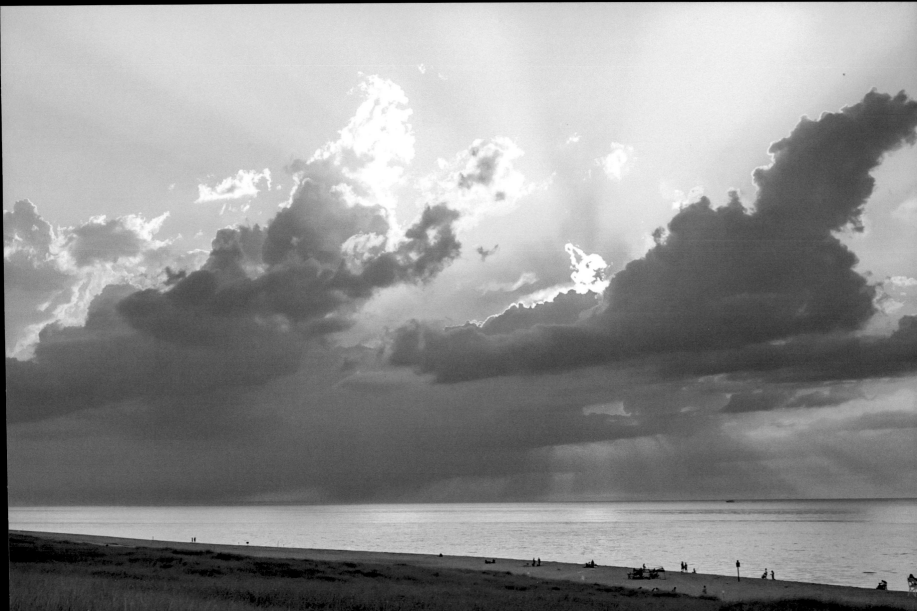

AUTUMN

Autumn may be the best time

of year on the Cape.

People are few,

the weather is mild,

and fall colors transform the

marshes, woods, and dunes.

The entrance to Lower Mill Pond, Brewster,
from Stony Brook Mill.

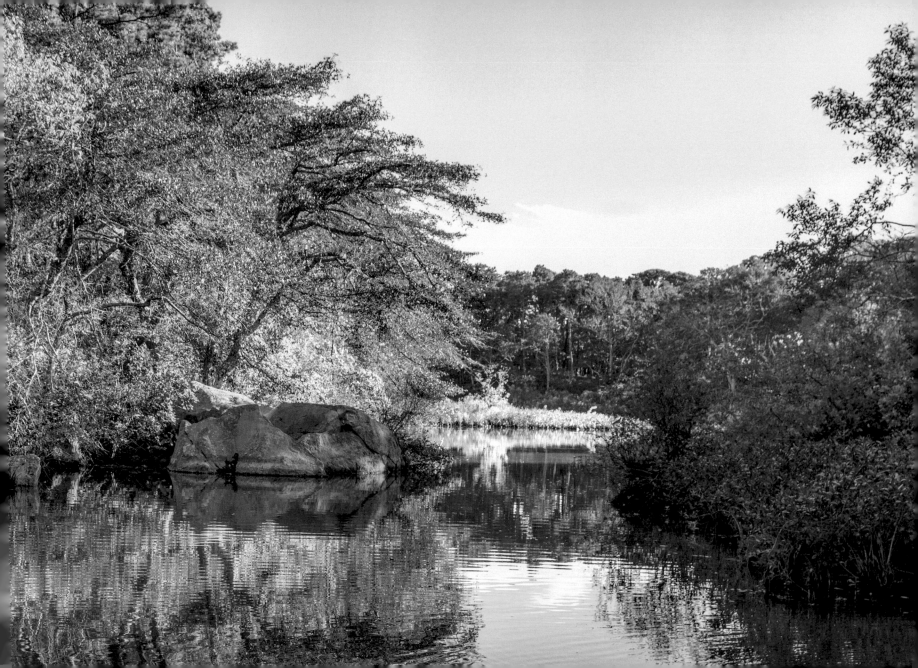

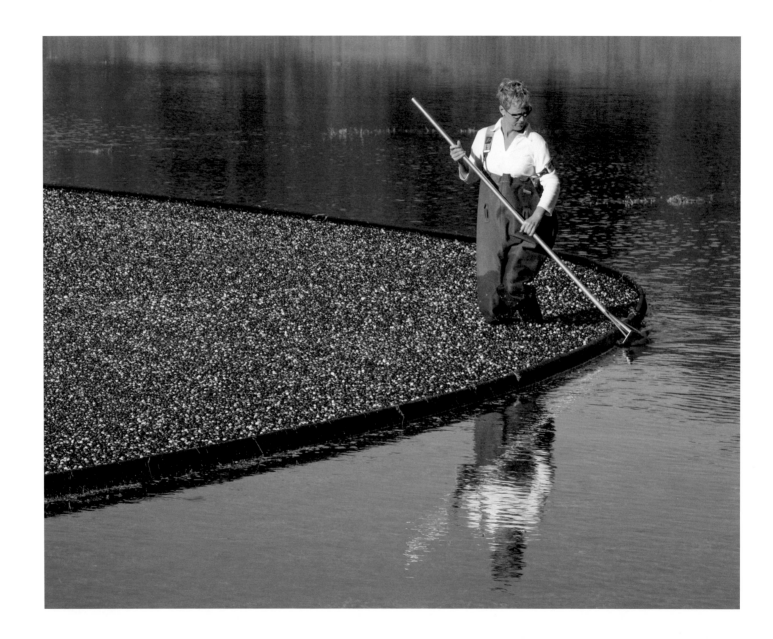

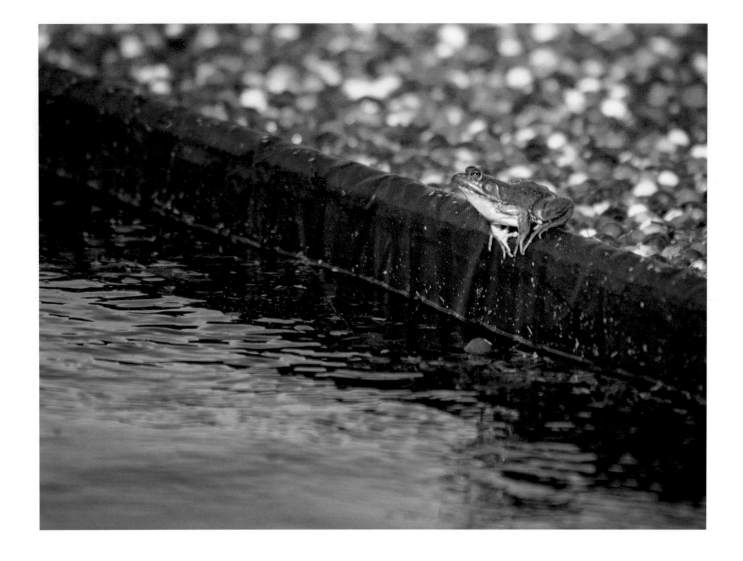

OPPOSITE Harvesting cranberries in Harwich. | Cranberry frog.

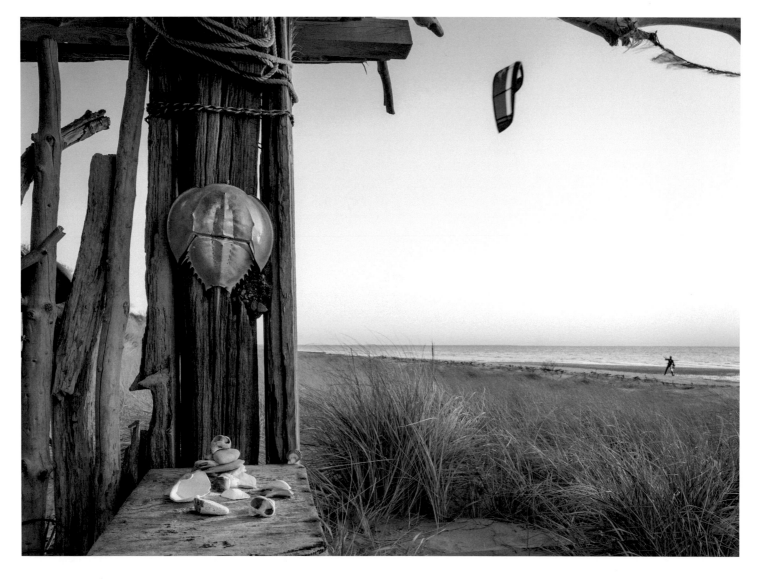

This shack was built from driftwood on the edge of Cape Cod Bay near Great Island, Wellfleet. | OPPOSITE Kayak fishing on Cape Cod Bay at sunset.

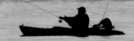

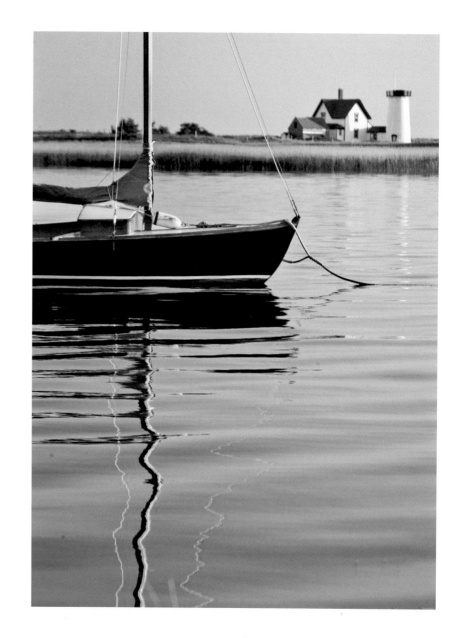

Looking across the Oyster River to Stage Harbor Light, Chatham. |
OPPOSITE Early morning clamming on Pleasant Bay.

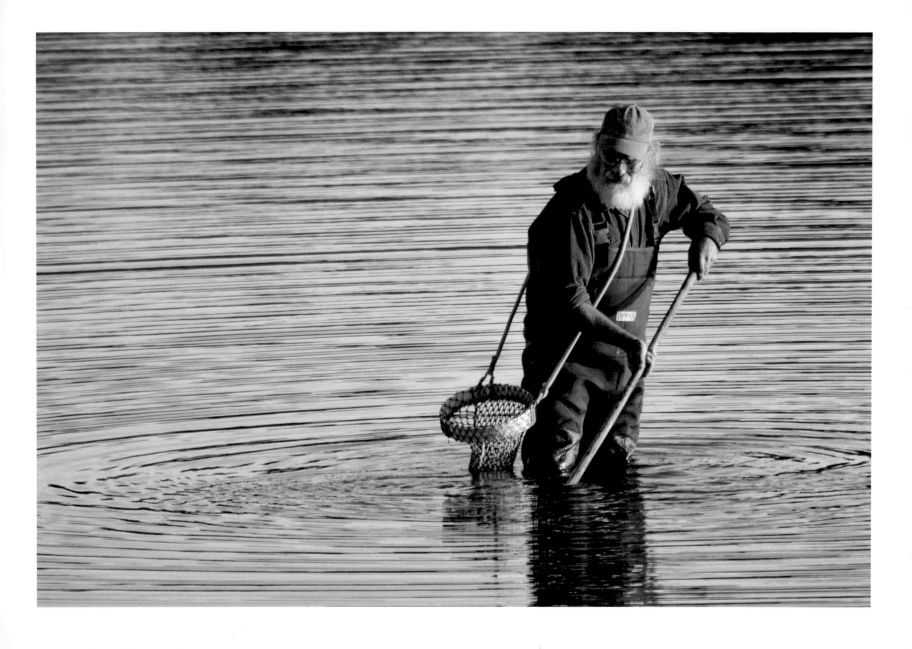

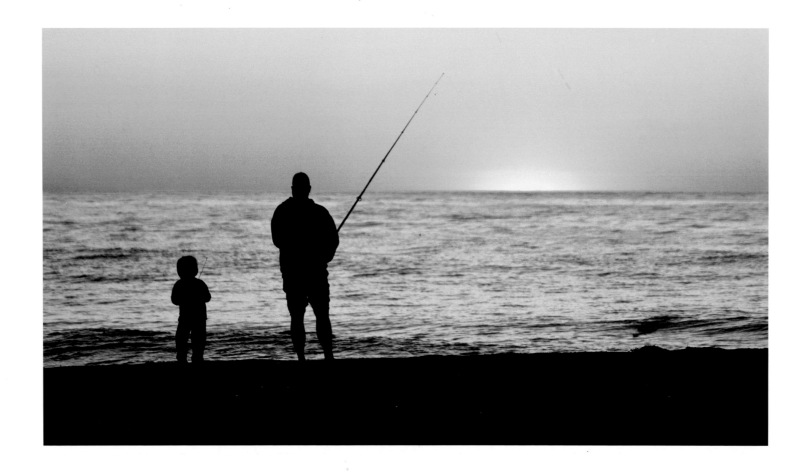

Beach fishing at sunset at Race Point Light. | OPPOSITE Red tail hawk at Fort Hill, Eastham.

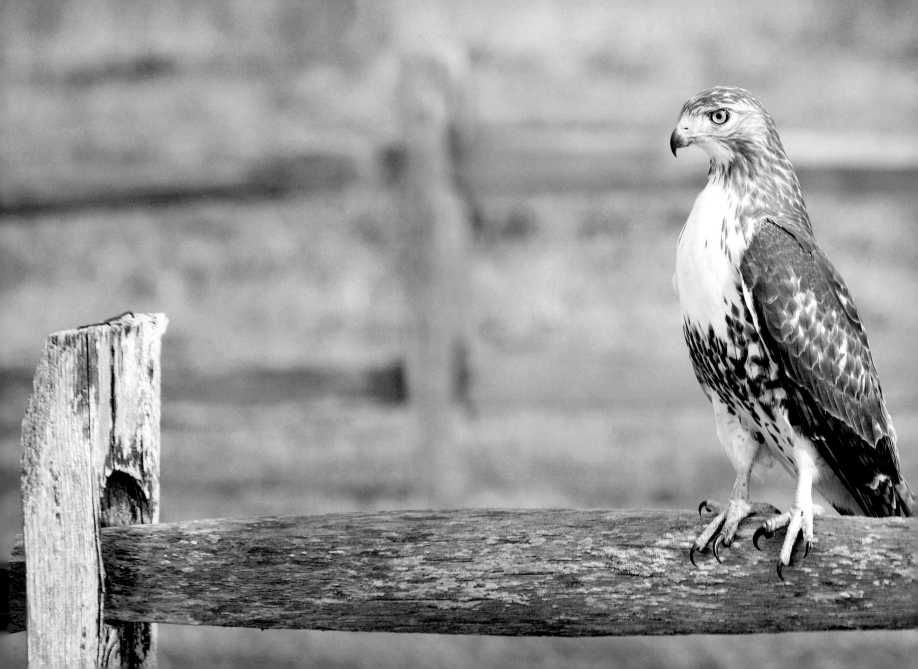

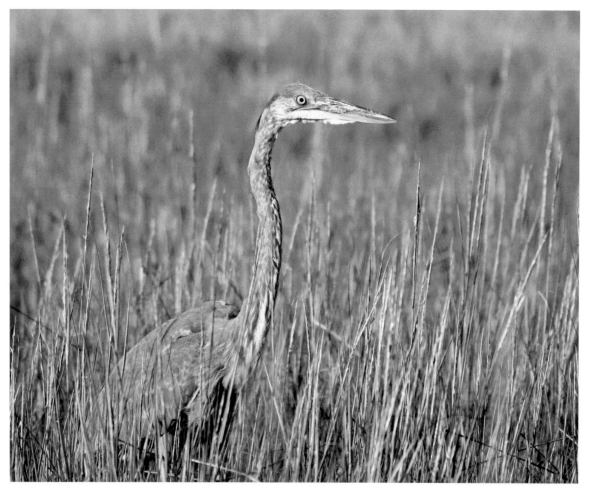

Blue heron. | OPPOSITE View toward Provincetown from North Truro.

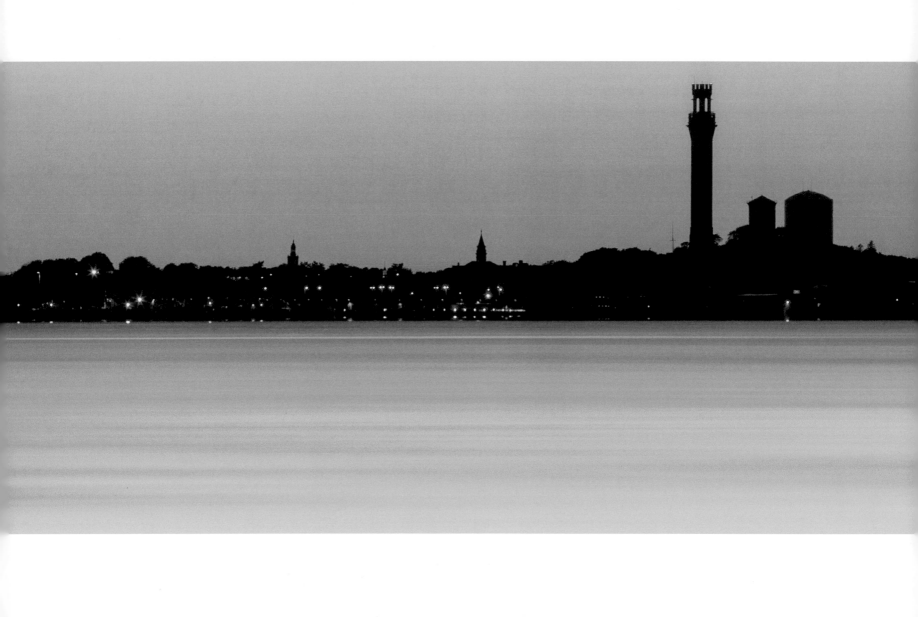

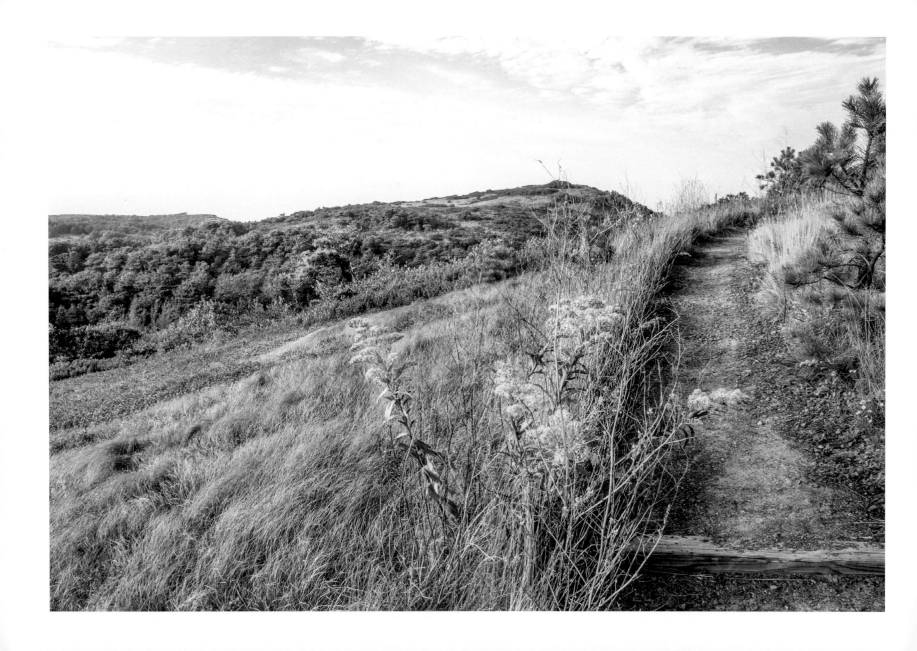

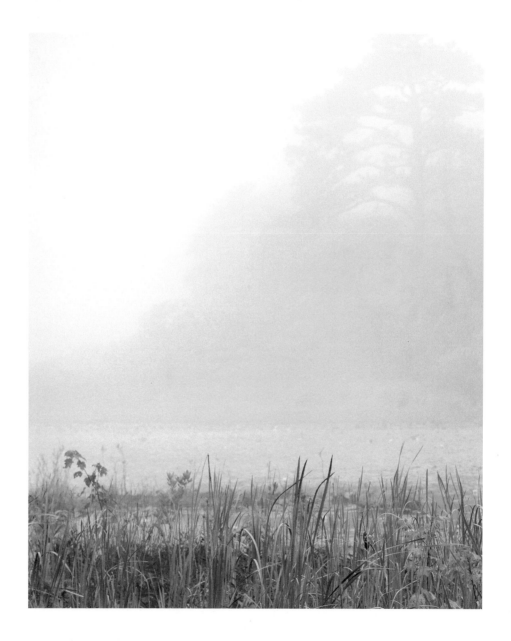

OPPOSITE Along the Pamet Trail in Truro. |
Misty morning in the Province Lands.

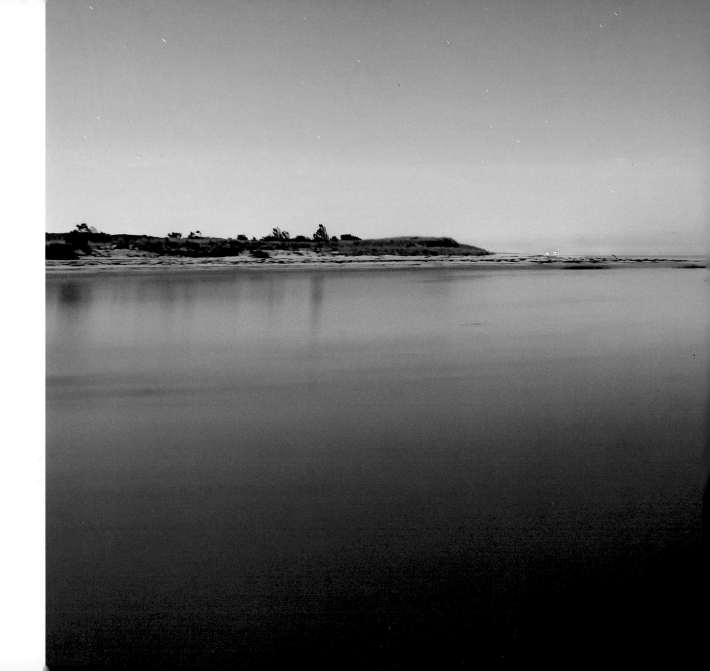

Night fishing at Paine's Creek.

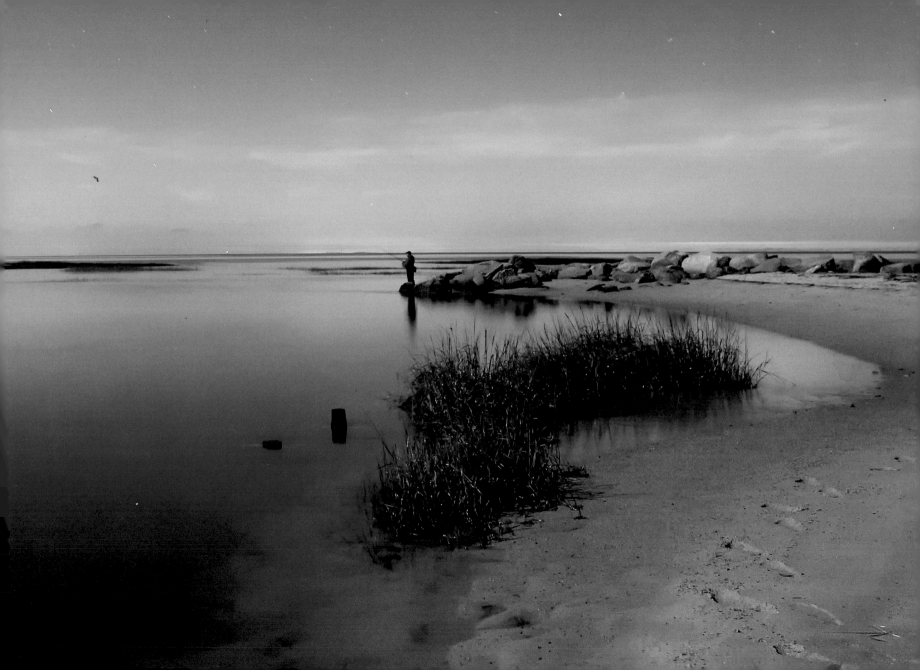

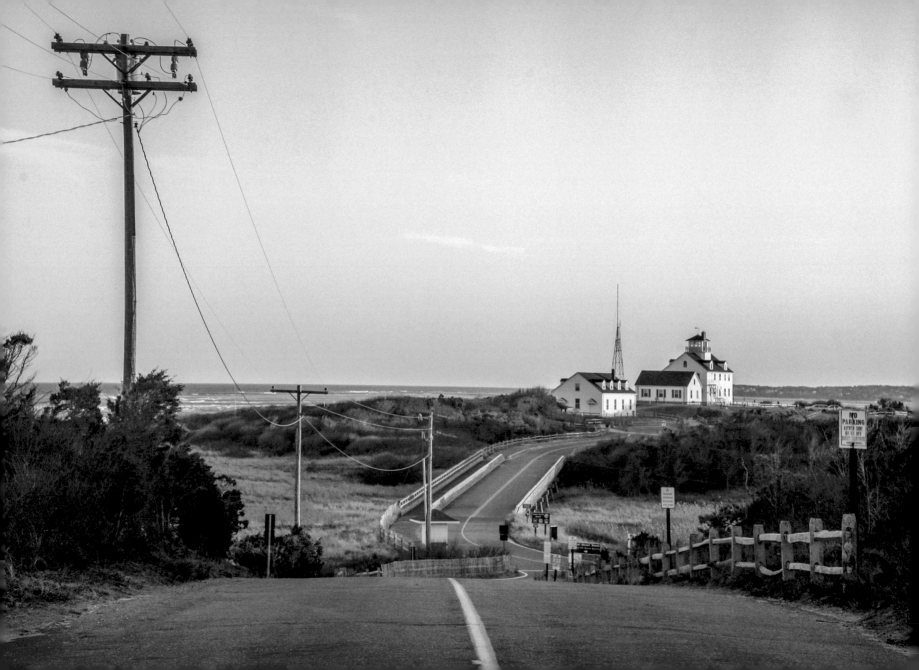

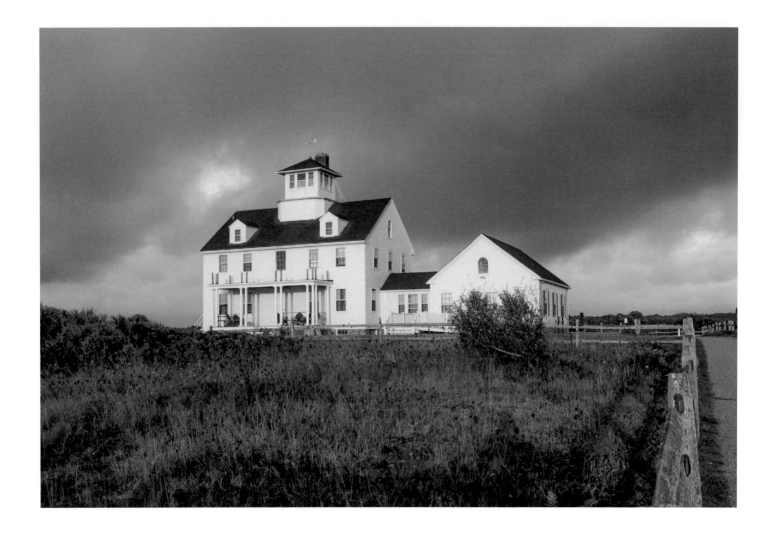

OPPOSITE The road to Coast Guard Beach. | The old Coast Guard station at Coast Guard Beach.

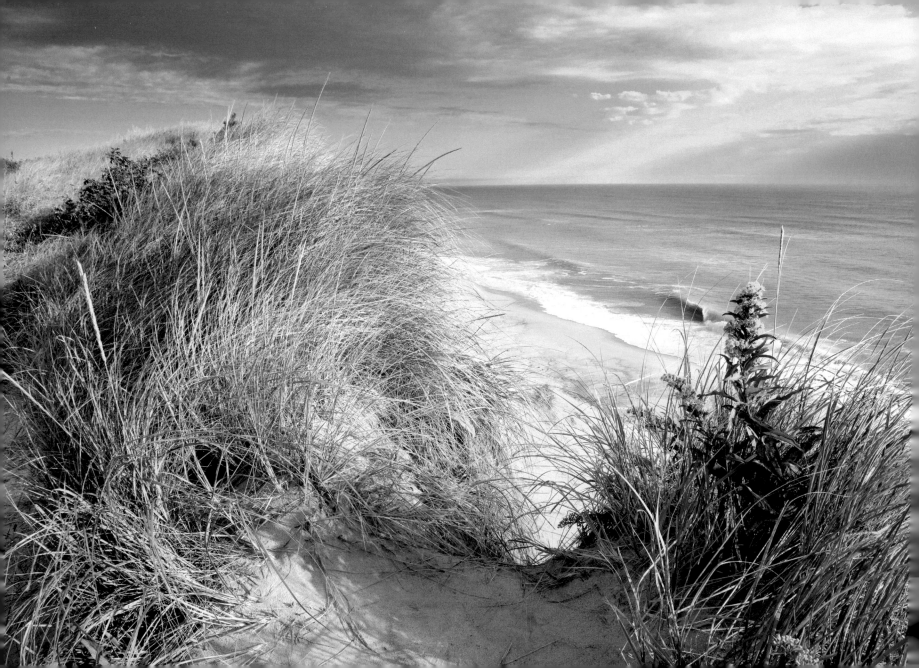

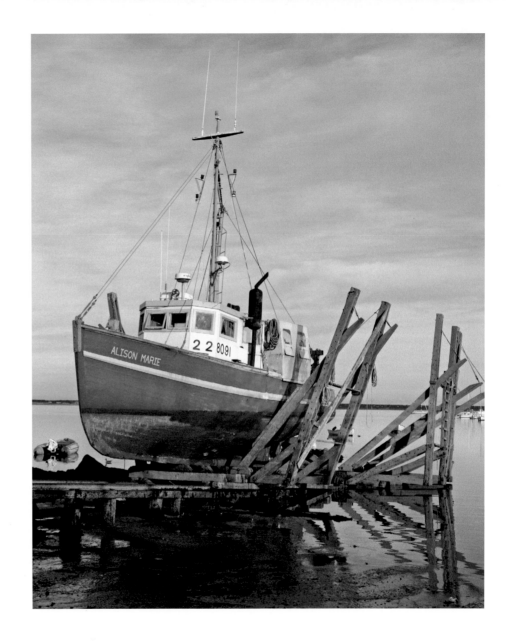

OPPOSITE Ocean view from the dunes in Wellfleet. |
Haul out in Provincetown.

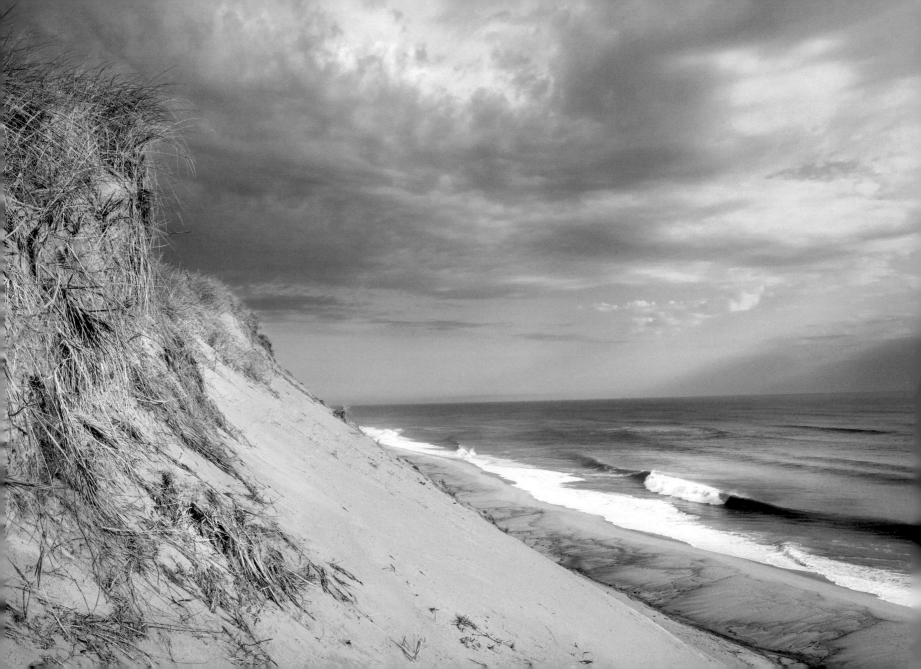

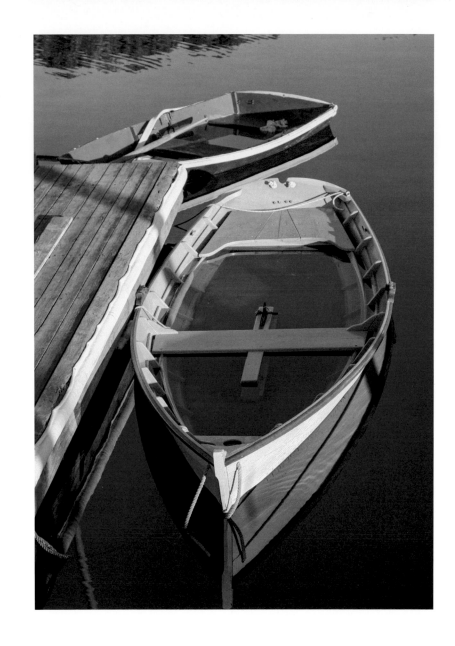

OPPOSITE Cahoon Hollow Beach, Wellfleet. |
Boats on Arey's Pond after a storm.

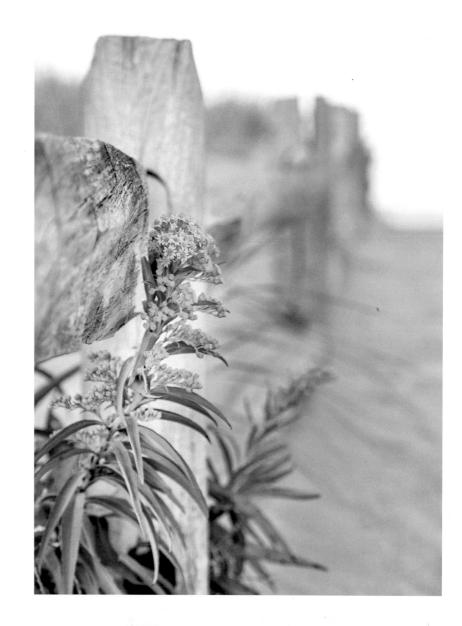

Goldenrod on the way to Nauset Beach. |
OPPOSITE Fog rolls in over Chatham Harbor.

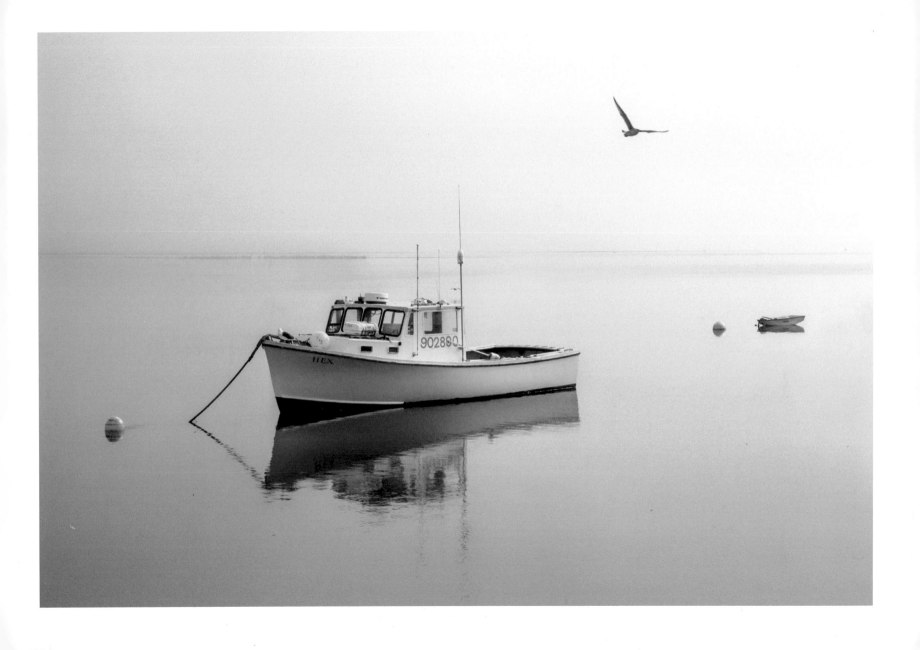

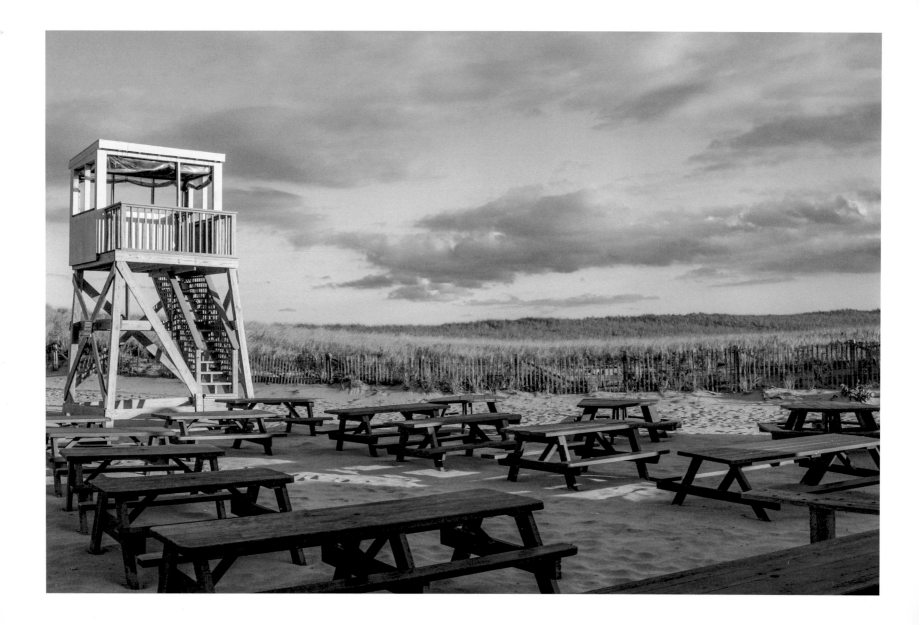

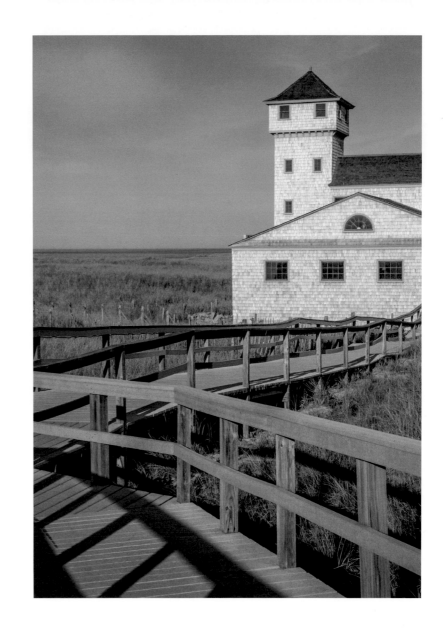

OPPOSITE Post season, waiting for summer. |
Old Harbor Life-Saving Station, Race Point Beach.

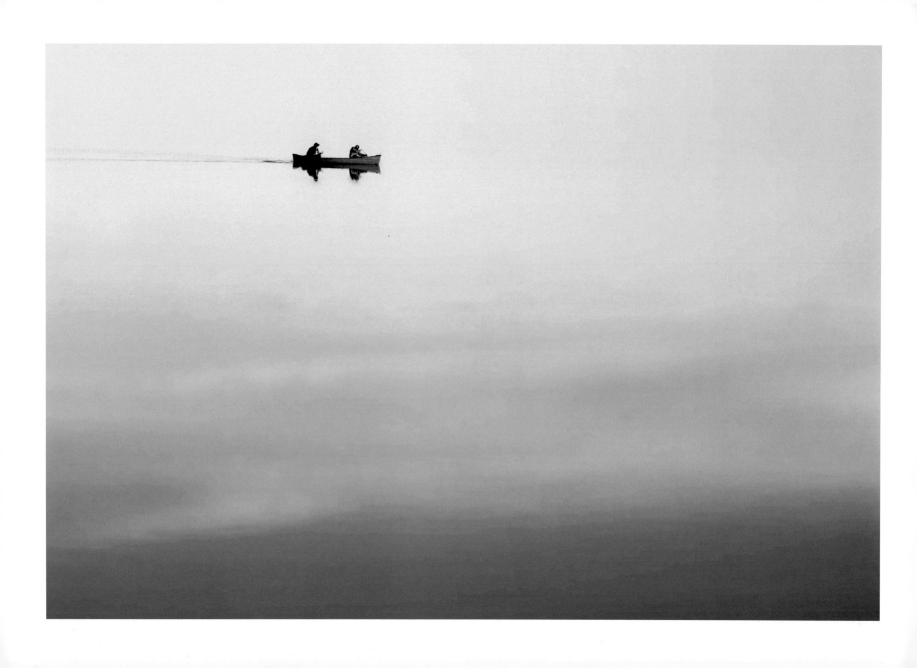

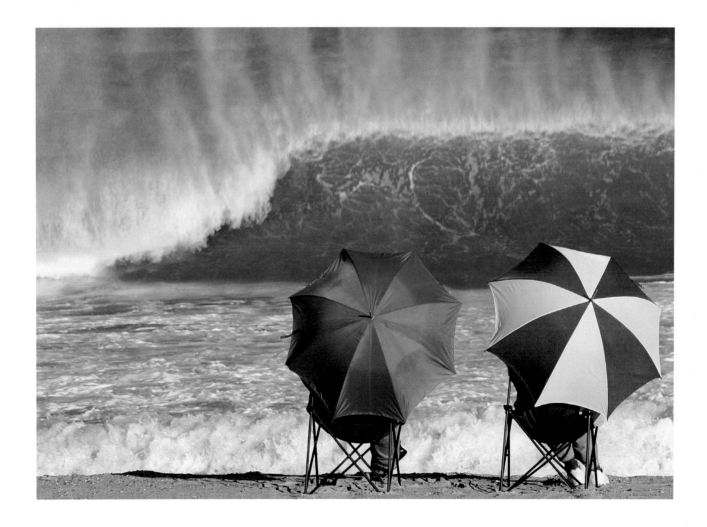

OPPOSITE Canoing on Nauset Marsh. |

A day at the beach. Spectators gathered on the beach to watch the large waves created after several days of strong wind.

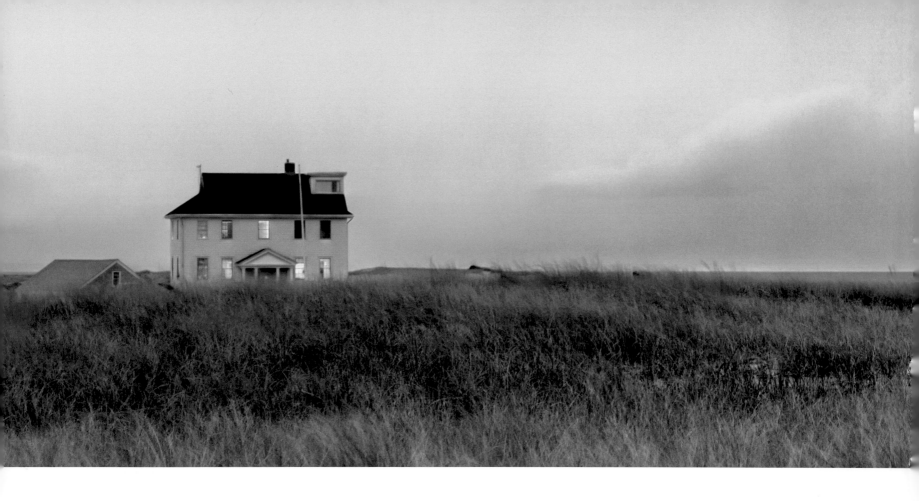

Coast Guard station at Race Point.

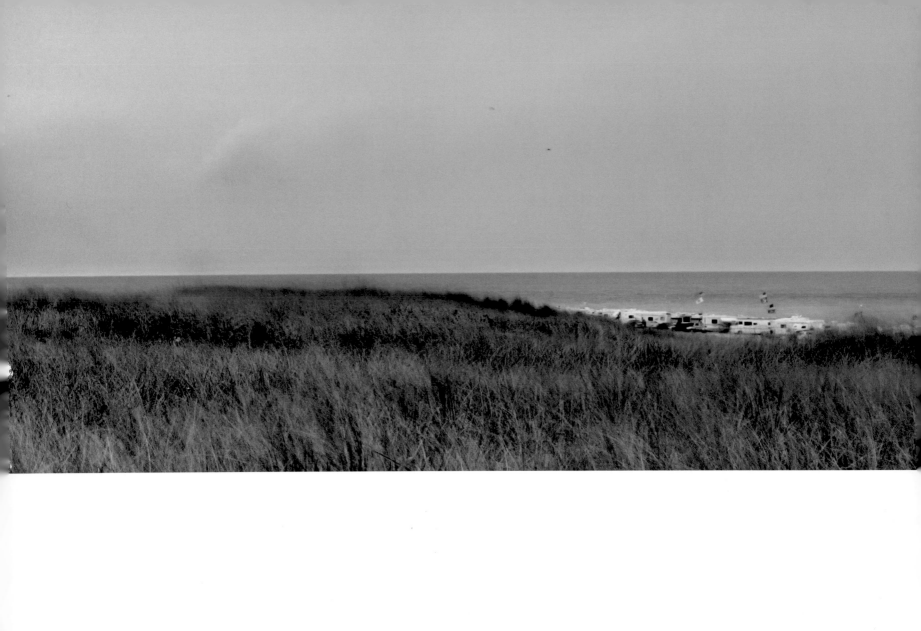

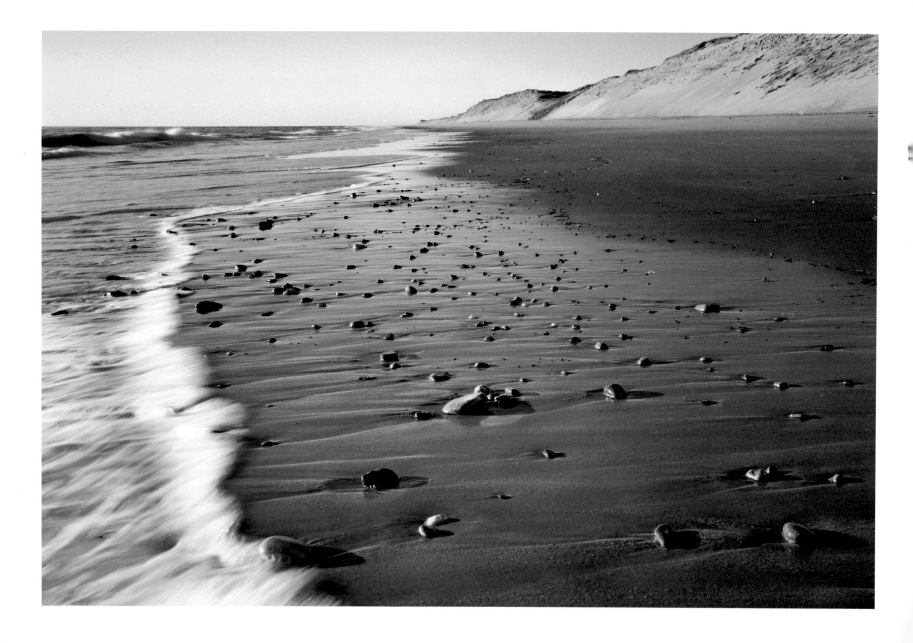

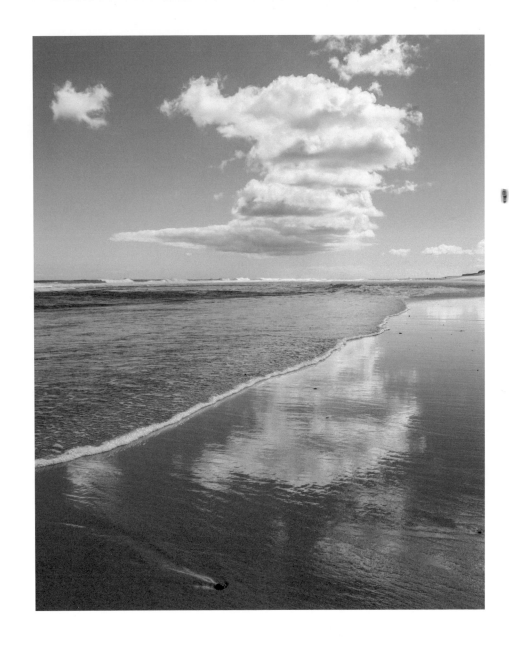

OPPOSITE Cahoon Hollow Beach, Wellfleet. |
Cloud over Coast Guard Beach.

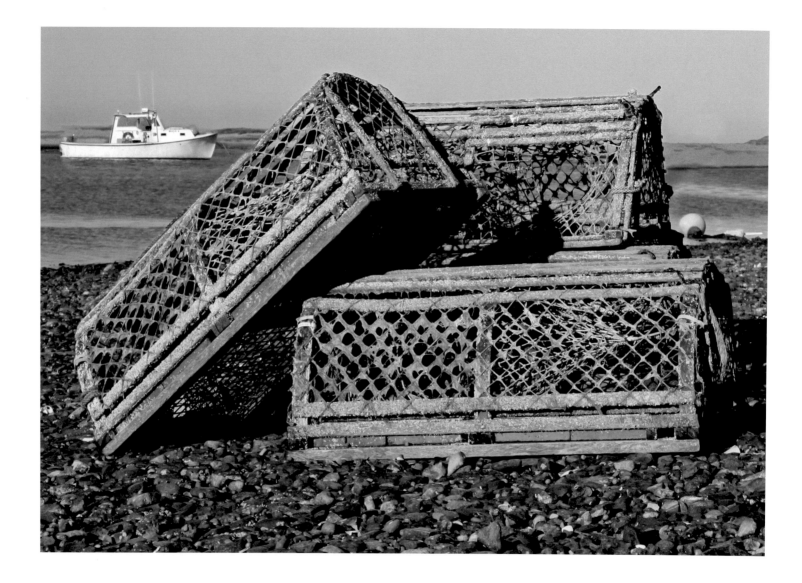

Lobster traps at Priscilla Landing, Orleans. | OPPOSITE Low tide at Hatches Harbor.

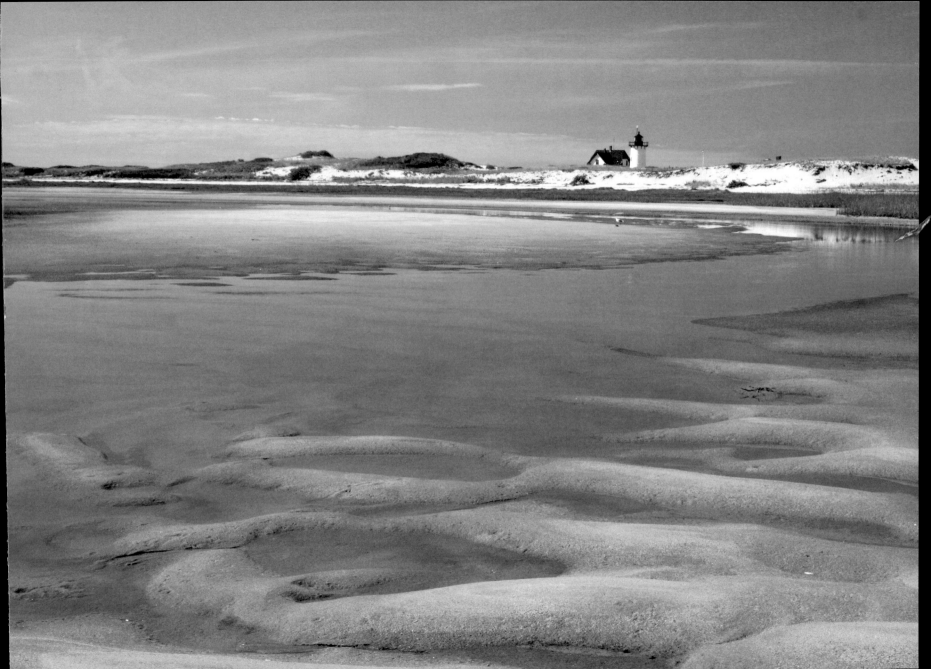

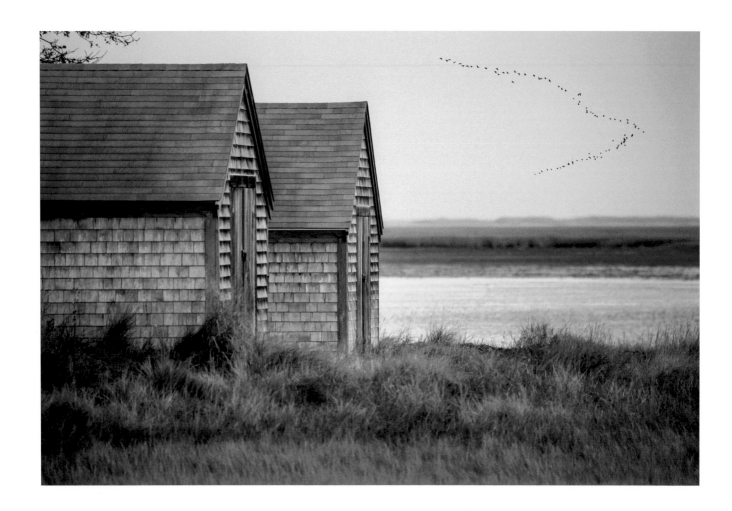

Nauset Marsh. | OPPOSITE Along the Salt Pond Trail.

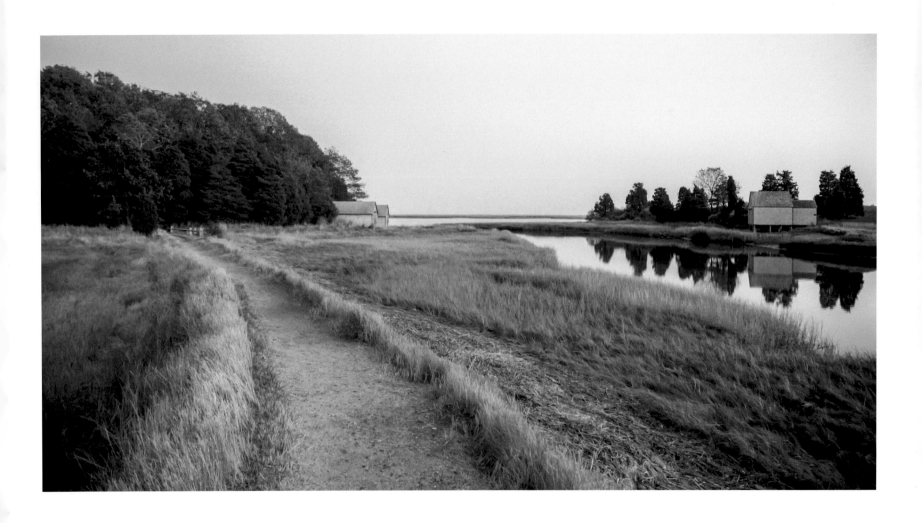

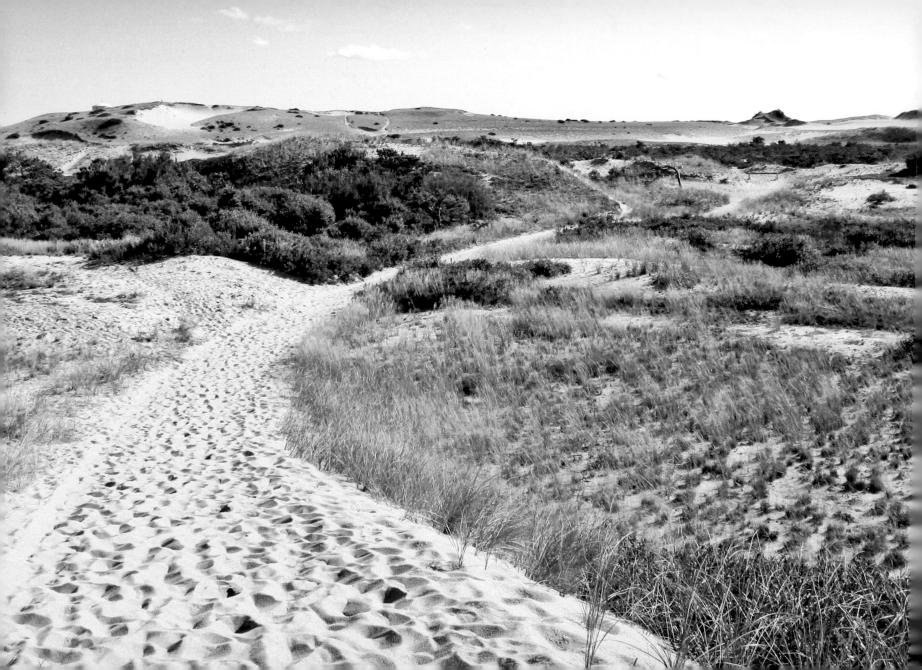

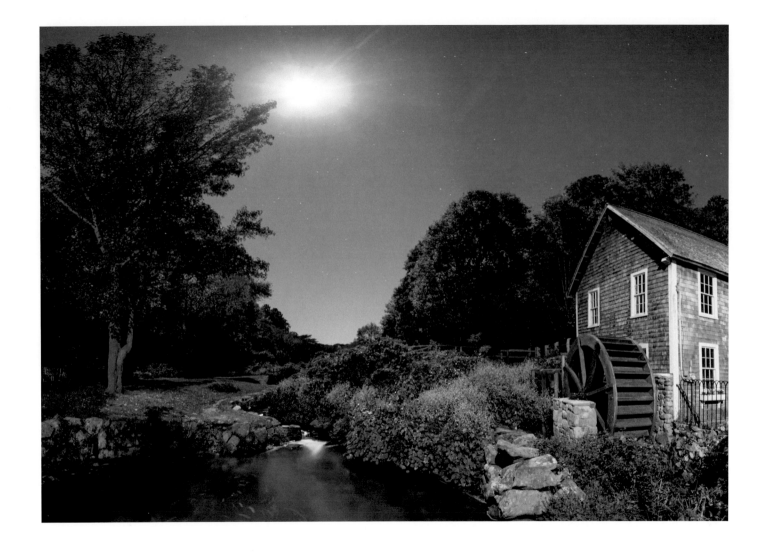

OPPOSITE Through the dunes of the Province Lands. | Stony Brook Mill at night.

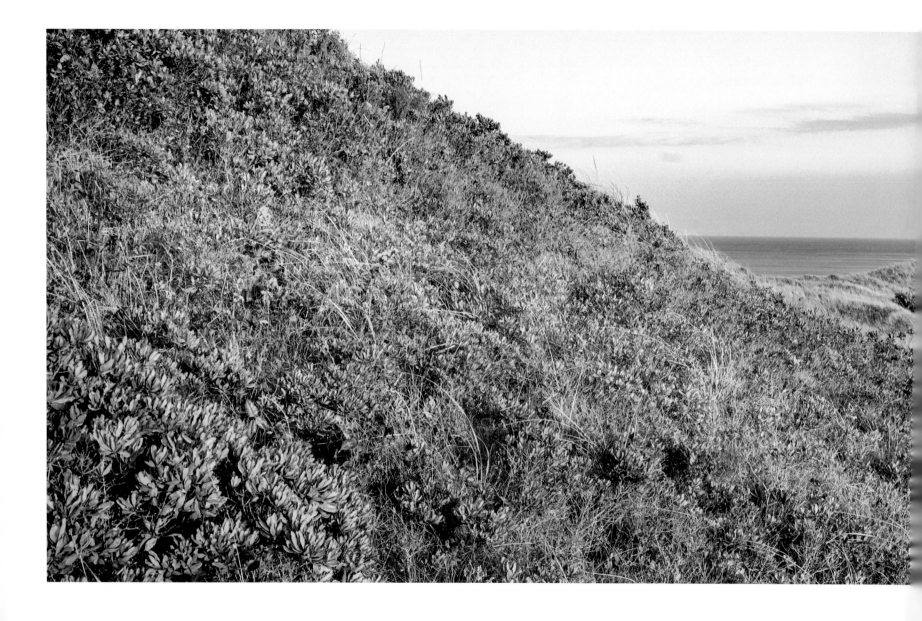

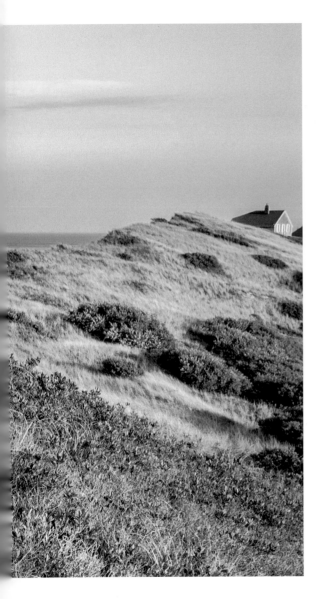

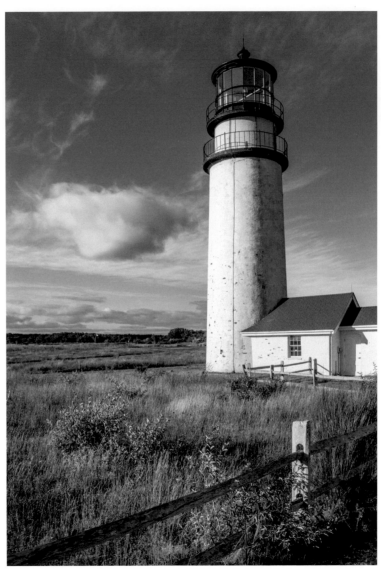

OPPOSITE Truro highlands. |
Highland Lighthouse, Truro.

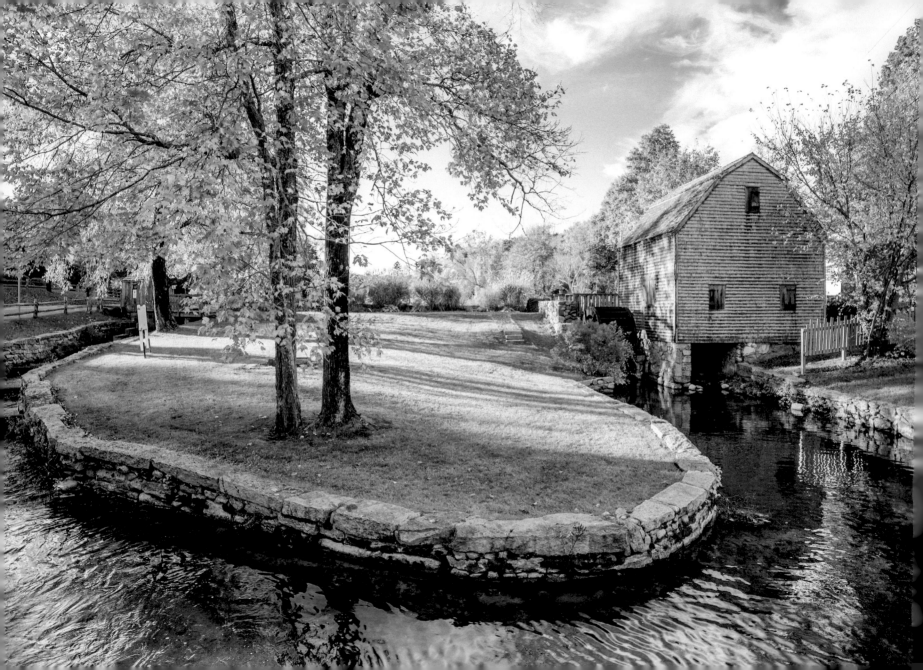

OPPOSITE Dexter Gristmill, Sandwich. |
Sunset at Stage Harbor Light.

AUTUMN

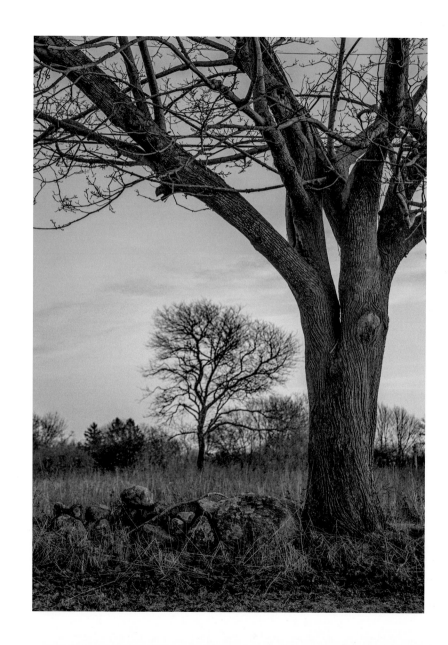

November evening, Barnstable. |
OPPOSITE East Sandwich Game Preserve.

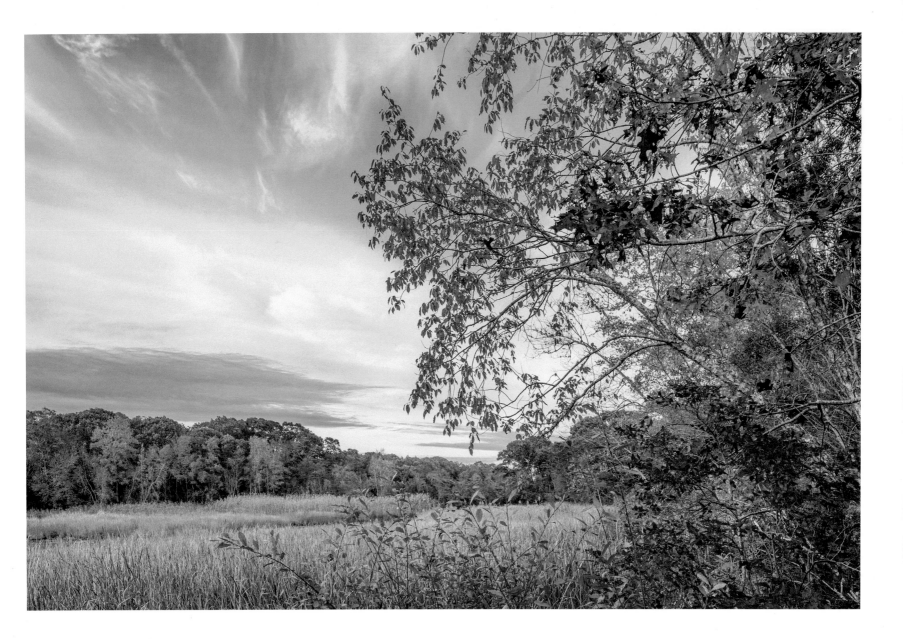

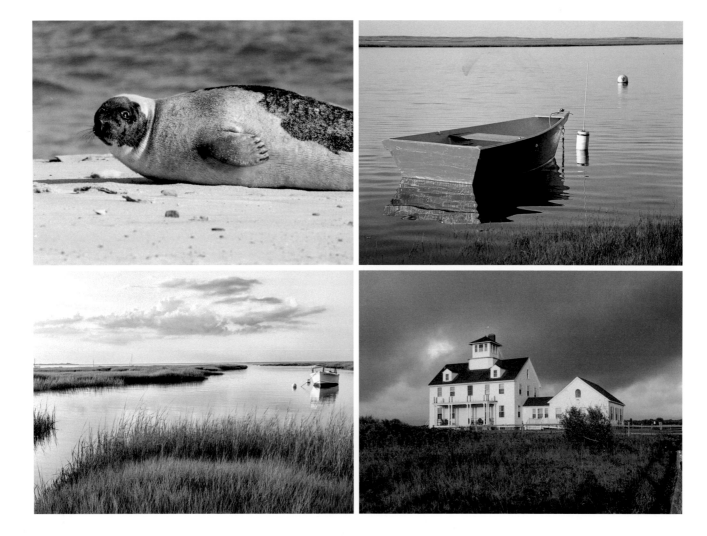